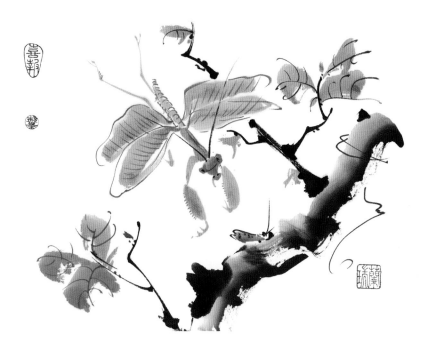

The Ch'i
of the Brush

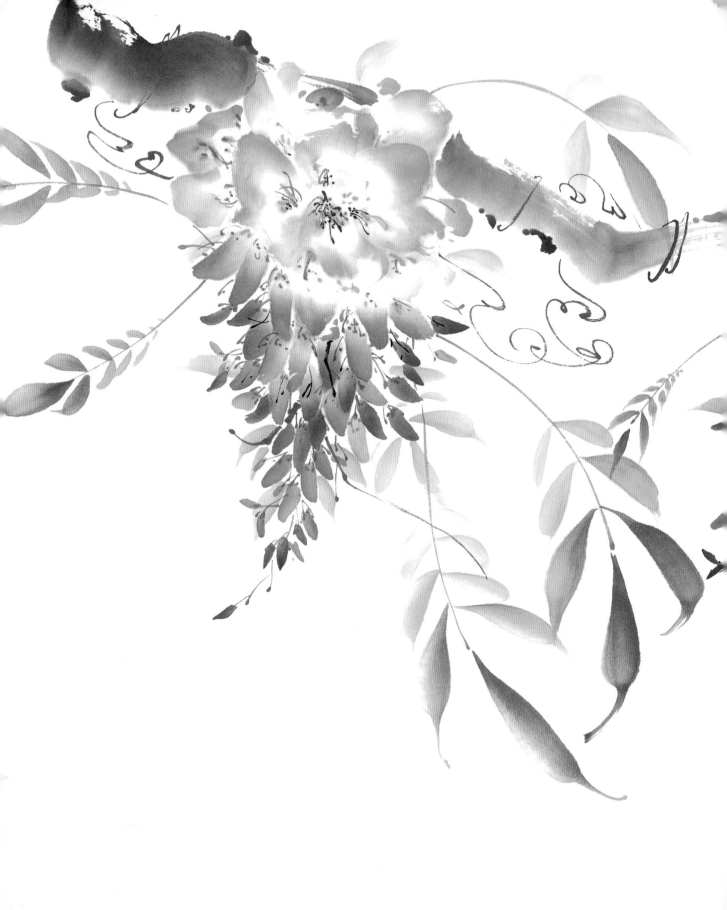

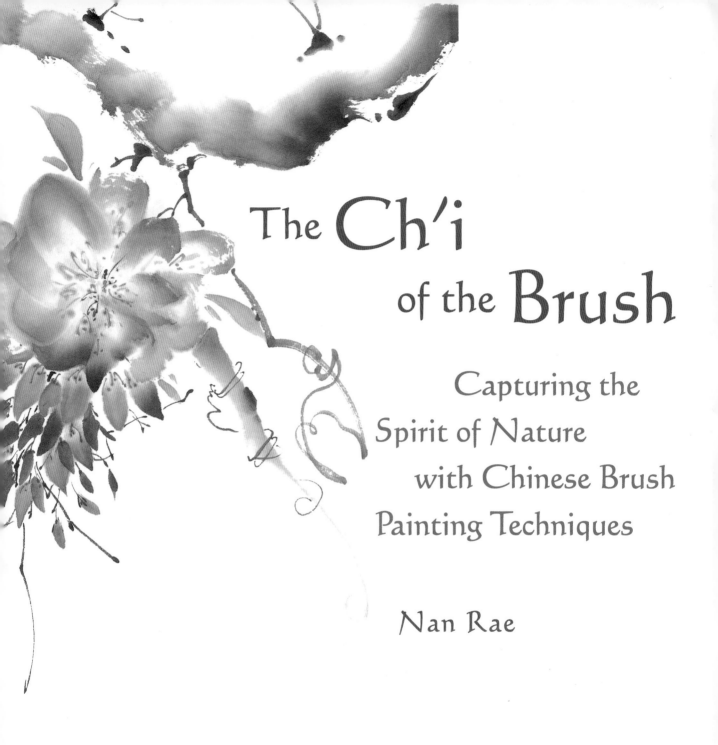

The Ch'i
of the Brush

Capturing the
Spirit of Nature
with Chinese Brush
Painting Techniques

Nan Rae

Watson-Guptill Publications • New York

Senior Acquisitions Editor: Joy Aquilino
Edited by Anne McNamara
Designed by Patricia Fabricant
Photography by Chuck Bowman
Graphic production by Ellen Greene
Text set in Calligraphic 421 and
Adobe Garamond

First published in 2003 by
Watson-Guptill Publications
a division of VNU Business Media, Inc.,
770 Broadway, New York, N.Y. 10003
www.watsonguptill.com

Library of Congress Cataloging-in-Publication Data

Rae, Nan.
 The ch'i of the brush / by Nan Rae.
 p. cm.
 ISBN 0-8230-0619-0 (pbk. : alk. paper)
 1. Ink painting, Chinese—Technique. I. Title.
 ND2068.R34 2003
 751.4'251—dc21

2003006171

Manufactured in China
First printing 2003

1 2 3 4 5 6 7 8 9/09 08 07 06 05 04 03

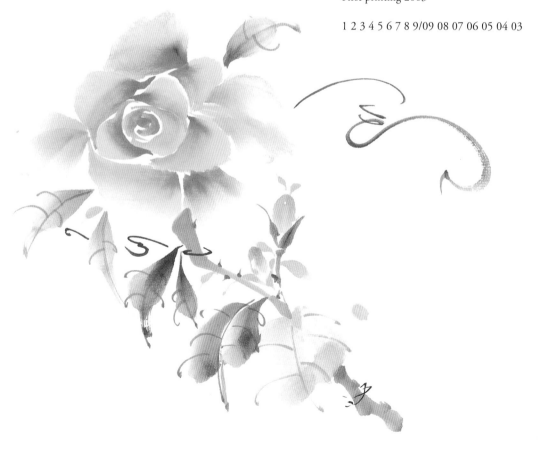

To Rosella, my beautiful mother, who always believed in me and dreamed beautiful dreams for me.

Acknowledgments

This book came into being through the vision of Joy Aquilino, Senior Editor at Watson-Guptill Publications. When I read Joy's proposal, I was inspired to bring the best book possible forward.

My husband Charles, partner, friend, and the love of my life, worked alongside me to turn my class material into what you now hold in your hands. Without his brilliance at the computer, his keen mind and sense of rightness, my lessons could never have taken book form.

Joan Catherine Khoury first opened the door for my Chinese brush painting adventure in 1984 and I shall forever appreciate her as I do the late Alice Marie Simon, who graciously opened her San Marino estate for my first classes. Gratefully remembered is my dear friend the late Gilbert Leong, artist, architect, mentor, and patron. This leader of the Los Angeles Chinese American community gladdened my heart by letting me know that "I had gotten it right!" Special thanks to James E. Folsom, Director of the world famous Huntington Botanical Gardens in San Marino, California, who asked me to teach Chinese brush painting at the Huntington seven years ago. Can an artist be in lovelier surroundings?

Many thanks to my editor, Anne McNamara, who absolutely caught the spirit of what I was saying. And thanks to Patricia Fabricant for her outstanding design.

The outstanding photographs in this book are thanks to Lisa Bowman, my angel-voice friend, who said that her movie director husband wanted to photograph me. It was a natural to have Chuck Bowman's photographs further enhance the book.

My profound gratitude to the thousands of students I have taught and the hundreds of patrons who have cheered for me each step of the way. Special thanks to my stalwart son Yanni, full of grace, a gifted teacher in his own right, who is always unfailingly supportive. To each and every friend who has loved me along the way, you are always in my heart. I am so blessed.

Contents

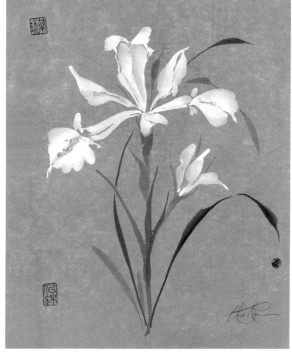

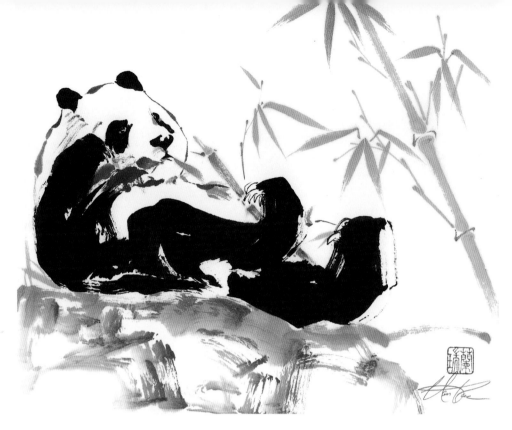

Preface

Ch'i ~ the essence or life force in an individual ~
the vital force of heaven.

This book is written for all of those with beauty in their hearts who long to bring expression to their innermost feelings and to convey the Chinese saying "from heart to arm…to hand…to brush…to paper." I promise you an amazing, wondrous journey!

> Amazing painting. Without drawing and without border…
> song without words…or art…without the help of forms.
> Without a sketch…without a story…without a fable…without allegory…
> Without body and without face…by the sole virtue of tone…
> It is all lyrical effusion.
> Where the heart speaks…surrenders itself…and sings its emotion.
>
> (LOUIS GILLET [1876–1943]
> upon seeing Claude Monet's painting, *Nympheas*)

A well spoken response to Monet's work. But toward whom did Monet turn for inspiration? After a grocer in Holland wrapped his purchases in Japanese woodblock prints, Monet had a moment of revelation. He asked for all of the grocer's prints, and is said to have remarked, "It was as if life shed something of its complications, becoming simpler, clearer, more intelligible and more beautiful."

Monet is my hero. What was his secret? What did he comprehend that so many others missed? I found the answer while visiting his home in Giverney, France. There, on the foyer walls, were the Japanese woodblock prints the artist so loved, with their purity of color, restraint, and understanding of the void—recognizing that space, empty space, is as important as the painted area. It is precisely these same qualities that drew me to Chinese brush painting. At that moment in Monet's home, my adventure in Chinese brush painting began. I have never looked back and neither will you.

Introduction

My teaching and lecturing over the years has convinced me that Chinese brush painting in the literati or free-form style is the most exciting, rewarding, and satisfying of any medium. This tradition was firmly established in the Yuan Dynasty, 1280–1368 A.D., and highly respected in the Ming Period, 1368–1644 A.D. The "gentlemen scholars" or "literati" were noblemen, men of means and influence. They were lovers of life who, with their artwork, joyously expressed their deep appreciation of the beauty that surrounded them. Capturing the very essence or *Ch'i* of the brush became their goal, as it is ours.

In Chinese brush painting, it is important not to conduct a running, critical commentary of your work. Please avoid the natural "adult" inclination to critique one's own painting. If you stay in a flow state, just like an athlete, your work will have excitement and vitality. As you connect with your work, your painting will tell you what it needs and when it is complete.

One of the main concerns for the Western artist is "artist's block." What to paint? With Chinese brush painting you are free from that—paint a flower, any flower. The blank piece of paper becomes an adventure instead of an angst-ridden terror. Remember, the goal is not botanical perfection, but work that reflects your heart and spirit.

It is also important to know that Chinese brush painting is about the journey and not the arrival. Each painting has a life of its own and will take a direction if you are willing to let it. Approach your artwork with child-like wonder and acceptance. Be willing to have happy accidents and exciting surprises—you will soon have a wonderful painting.

In this book, we are studying floral as well as animal subjects. Do not expect to be satisfied with your work on your initial attempts—no one ever is. Yet, dare to do it—jump in with both feet because you will be learning. Practice, patience, and determination will pay off in more than artistic achievement. You will find yourself on a voyage of self-discovery, finding contentment and assurance as you explore and express your inner spirit. Your inner spirit will give what you ask of it and what you train it to do. That is the supreme lesson of Chinese brush painting: learn and be rewarded.

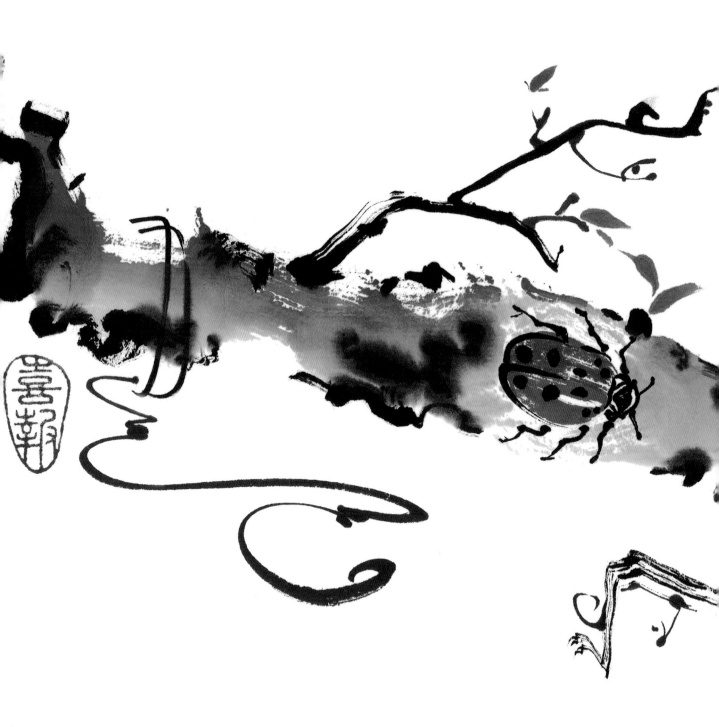

Part One

Information
for the
Journey

The Roots of Chinese Brush Painting

Calligraphy, the art of producing beautiful writing, has always been the highest art form for the Chinese. Indeed, calligraphy is the art form from which all other Chinese art forms flowed and evolved. Although our lessons do not deal with calligraphy, it is altogether fitting that we make a proper bow to this worthy ancestor of brush painting.

The mastery of Chinese calligraphy requires many years of dedication, serious study, and self-discipline. It is one of the world's most demanding art forms and the Chinese nobility, especially the genteel literati, were intellectually compelled to devote an important part of their lives to its practice and study. They vied with one another to achieve a level of excellence and perfec-

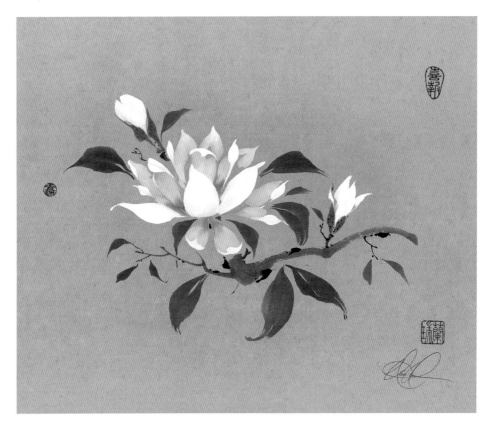

tion, which would win for them the coveted public recognition so often sought by the scholarly elite.

From calligraphy evolved the beauty and harmony of Chinese brush painting. The earliest paintings were monochromatic black ink paintings. In the East, black is considered a color; it has profound meaning and importance and takes its place in the Asian "rainbow" of colors. Any of the subjects in this book may be painted with great success using only black ink.

The strokes employed in brush painting were developed in the 5th century in China and the 9th century in Japan. The Chinese articulated, defined, and codified the techniques, while the Japanese later made significant contributions of their own. Early ink and wash landscapes relied on vivid brushwork and varying intensities of ink to express the artist's conception of nature and his own ideals and character. By the 9th century, flower-and-bird painting developed into an independent genre whose subject matter included a variety of flowers, insects, and fish. These subjects were rendered with ink and brush using a minimum of strokes for maximum effect.

To achieve freedom, spontaneity, and boldness, the emphasis in brush painting is on the idea. In fact, this type of painting is referred to as "written idea." Visualization of an idea, which requires much thought and devoted practice, is required before touching brush to paper. Through visualization, the artist's mind, soul, artistic motivation, and inner beauty is brought forth to create art that is unique and spirited.

In Chinese brush painting, brush movement is a cardinal element. The distinct nature and properties of the various brushes readily reflect the movement of the brush, thus supporting the artistic integrity of each stroke. For this reason, the artist never corrects the original brushstroke, as it would betray crudity and clumsiness to do so and would diminish the straightforward honesty of the artistic effort. Strokes that are contrived or labored lose the light and airy elements of freedom and spontaneity. Chinese brush painting is contemplative and complex with ostensible simplicity. This dichotomy is extremely important to Chinese painting.

> ...If you aim to dispense with method, learn method
> ...If you aim at facility, work hard
> ...If you aim for simplicity, master complexity
>
> Lu Ch'ai, Master of Ch'ing Tsai T'ang, 17th century

Styles of Chinese Brush Painting

Chinese brush painting is executed in many modes or styles, and dates from the Han Dynasty of the 3rd century A.D. We will use the *Hsieh-I* or "written idea" style originated by Chao Meng-fu (1254–1322), which simply put is the expression of emotion in painting. This innovation shaped all later artistic development in China. With our brush, we will express what we feel in our hearts.

Painting rapidly in the *Po-Mo* or "throw ink" style, we will use no drafting lines and will make no corrections. Our goal is a spontaneous and free spirited effect, which you will achieve in due time as you master the Chinese brush technique. The subject you paint will take form entirely by brushstrokes without outlining. This style or mode of painting is called *Mo Ku*, meaning "boneless." *Mo Ku* may be combined with the outline/contour style called *Ku Fa* (for an example, please refer to the Narcissus lesson beginning on page 42).

The more spontaneous your brushwork, the more expression you will convey. Your paintings will have a unique and personal style, with every touch and flourish emanating from your full life experience. The immediacy and fluidity of the brushwork is empowered by your *Ch'i,* or life force. While it is important to follow rules and principles during the early learning period, it is important not to be overly concerned with these—just let go and paint with abandon.

Remember that Chinese brush painting is meant to be more than a mere representation of an object, but also a symbolic expression. A full plant is never painted, but rather a few blossoms will represent the plant in its entirety and, in fact, all of life itself—a *Tao* principle. Paint without looking at the subject. Instead, bring it forth from your mind and heart and feel at one with nature.

The Six Canons of Chinese Brush Painting

The techniques of Chinese brush painting have been codified. The most notable codification was formulated in the 5th century A.D., by the venerated master, Hsieh Ho (circa 500 A.D.). Hsieh Ho wrote the "Six Canons of Painting" that form the basis of all Chinese brush painting down to this very day.

1. "Circulation of the Ch'i (Breath, Spirit, Vital Force of Heaven)—Producing Movement of Life"

 This is in the heart of the artist. The whole purpose of brush painting is to express the *Ch'i* or life force of the painter and for this reason paintings are best done freely and in one sitting.

2. "Brush Stroke Creates Structure"

 This is referred to as the bone structure of the painting—the stronger the brushwork, the stronger the painting. Character is produced by a combination of light and dark, thick and thin, wet and dry, and smooth and rough strokes.

3. "According to the Object, Draw its Form"

 Draw the object as you see it. In order to do this, you must first understand the form of the object. This will produce a work that is not necessarily realistic, but real as *you* perceive it. The more you study the object to be painted, the better you will express its nature, keeping in mind that expression is superior to beauty. In brush painting, the merely decorative is thought to be inferior to contemplative work.

4. "According to the Nature of the Object, Apply Color"

 Black is considered a color and the range of shadings it is capable of in the hands of a master painter creates an impression of a variety of colors. If other colors are used, they are always true to the subject matter.

5. "Organize Compositions with the Elements in their
Proper Place"
Space is used in Chinese brush painting the same way objects are used.
Space is an integral part of the composition.

6. "In Copying, Seek to Pass on the Essence of the Master's
Brush and Methods"
To the Chinese, copying is considered most essential, and only when the
student fully learns the time-honored techniques, can he branch out into
areas of individual creativity.

The Eight Principles of the
Nan Rae Atelier

In addition to the Six Canons, I have developed a list of my own principles,
or guidelines, for Chinese brush painting.

1. "Know Your Subject"
To paint with complete abandon, it is essential to know your subject.
Sketching is wonderful for learning and I recommend strolling through
gardens, taking cuttings and sketching, sketching, sketching. Observe how
the buds form, how the petals open up and then fall, and how the stamen
are placed. You will be amazed at how much there is to see.

2. "Be Surprised—Seek and Embrace the
Unexpected"
On your intuitive journey, drink in the beauty that
surrounds you, and then explode with inspiration.
If certain parts of your subject speak to
you, go with it—enlarge
or intensify them.

3. "Leave Serious at Your Studio Door"

Delight in your adventure. Remember there is no one like you and no one else can express the world about us the same way as you can. Enjoy this individualism. Flaunt it!

4. "Give Your Brush Life and Paint with Authority"

Line is always alive, never static. Even while you paint deliberately, remember to be spontaneous.

5. "Let Spontaneity Reign"

This will help you achieve Rule #4. Your masterpiece will be lively—it will dance!

6. "Don't Worry About Likeness"

Capture the spirit of your subject. Remember that if you merely copy nature, you are presenting only its surface. All of your subjects will take on deeper meaning as you observe them in a conscious manner, aiming to understand and connect with their essence.

7. "Connect with Your Work"

Let your thoughts and feelings surge through your work. Expression is all as you convey the very *Ch'i* of nature.

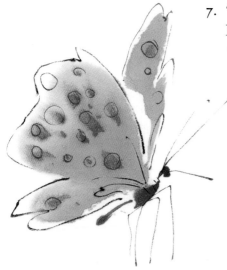

8. "Be Daring"

The Ming (1368–1644) and early Ch'ing (1644–1911) Dynasty artists were daring and their compositions were unpredictable. Let the work just happen as you create, free of the burden of self-doubt and second thought.

Materials
The Four Treasures of Chinese Brush Painting: Ink, Slate, Brush, and Paper

These tools of artistic expression were so highly valued in China that they became known as the Four Treasures.

Ink

The Ink is in stick form, the best being made from burnt pinewood soot mixed with animal glue. This process was developed around 200 B.C. So highly prized is the Ink-maker's art that a gift of a fine ink stick is a mark of high honor. If you plan to use an Ink stick, purchase the best one available.

Ink Stone

Ink is ground on an Ink stone, which is usually made of slate (you do not need an expensive Ink stone). Place a few drops of water in the well or bottom of the slate and rotate the Ink stick. Hold the stick gently but firmly in a vertical manner, keeping in mind its fragile nature. If needed, add a few more drops of water after a minute or so. The Ink is ready when you see little bubbles appearing as you grind.

Dry the wet end of your Ink stick by tapping it gently on a paper towel. Store the Ink stick in a flat position. Remember to clean your slate after each use as Ink does not reconstitute and dried Ink will ruin your slate.

I have found that a good quality, bottled Chinese Ink works very well, and that is what I have used for several years. However, grinding Ink offers a moment of serenity and contemplation. Any of the subjects in this book may be painted in Black Ink only, as Black is not only considered a color, but believed to contain all five of the basic colors.

Brushes

Brushes were invented around the 5th century B.C. in China. During the Chin Dynasty (265–419 A.D.), they evolved into the sophisticated constructions we use today. Chinese brushes are extraordinary wonders, marvels of design, and all painting in the Asian manner is totally dependent upon them. A Western brush cannot come close to achieving the expressive qualities of a good Chinese brush.

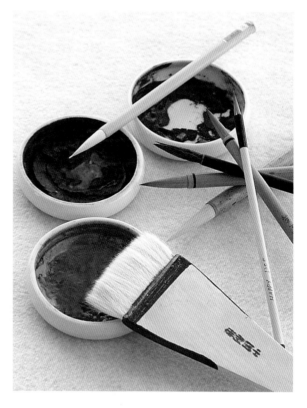

Superb craftsmanship goes into the forming of each handmade Chinese brush. In the center of the brush, there is a long core surrounded by shorter hairs, forming a space that acts as a moisture reservoir. Over these two layers, the exterior hairs come to a fine point, no matter the size of the brush.

New brushes have a coating of glue and need to be soaked in warm water for five to ten minutes to remove it (some brushes may take longer). When soaking, it is important not to allow water above the top of the brush hairs, as that will weaken the glue attaching the hairs to the handle. Test for any residual glue by pressing the hairs between your fingertips; when you no longer feel a hard core, the glue is gone and the brush is ready for use. At this point, rinse your brush in cold water and dry it on a paper towel, making sure that all of the hairs are in a straight line and the tip of the brush comes to a point. Never leave a brush soaking in water after removing the glue; it will shorten the life of the brush.

It is not necessary to clean brushes with soap—just lots of rinsing and patience will do. Always lay a brush down flat or hang it by the attached cord to dry. Take care that the hairs are aligned and never twisted. Never attempt to return your brush to its original protective cover after soaking; the brush will have expanded in size and will be damaged if forced back into the cover.

Hard Brushes

Hard Brushes are usually made with wolf or deer hair. Because of their bounce and resiliency, these brushes are the most responsive to the artist's touch—they literally dance across the paper. Hard brushes hold their shape when used, and it is possible to get several strokes without having to re-form the tip. The hard brushes we will be using are the Happy Dot, Best Detail, Big Idea, and Large Orchid Bamboo.

The three brush classifications are hard, soft, and combination.

Happy Dot (B): A Happy Dot brush is used to paint stamen, birds' beaks, very small dots, and for fine line work. This is the best detail brush because of its fine tip and excellent control.

Best Detail (C): The Best Detail brush is similar to the Happy Dot, but it is somewhat fuller. Use this brush to form a small stroke with a rounded aspect.

Big Idea (D): A Big Idea brush is an all-purpose brush used for small- to medium-size branches, small petals, leaves, and dots. This brush is sometimes considered a small Orchid Bamboo brush.

Large Orchid Bamboo (F): A treasure! You will find that this brush is the most responsive and most reliable. As its name describes, this brush will produce the best orchid and bamboo leaves, and it is also excellent for line and stem work. It has the most bounce, a very fine tip, and its thick body produces a wide, silky smooth stroke.

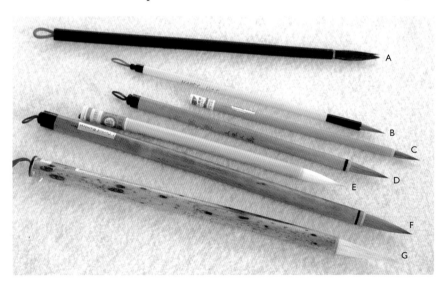

Later, as you master these hard brushes, you may want to paint even larger strokes; for that you would use a Tiger I or Tiger II brush.

Soft Brushes

Soft brushes—made of sheep, rabbit, or goat hair—work like a mop and are used to produce a smooth, wet stroke. For this reason, water retention is the essential feature of a soft brush. Because they have no spring or bounce, soft brushes lose their shape once pressure has been exerted on them, giving the artist little control.

Medium Soft Brush (E): A Medium Soft brush is used to paint the bodies of small birds and fish.

Basic Soft Brush (G): The Basic Soft brush is used to paint pandas, large branches, fish tails, and some leaves.

Hake or Large Wash Brush (below): This brush is used to wet the entire paper and to paint background washes.

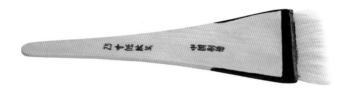

Specialty and Combination Brushes

Combination brushes are made of a mixture of soft and hard hairs. The hard bristles are usually on the inside, with the soft bristles on the outside. These brushes are used to develop large, soft shapes. Combination brushes have some of the moisture retention of soft brushes, while offering more control like a hard brush. We will not be using combination brushes in our lessons.

Mountain Horse Medium (A): This specialty brush is made from horse hair and is very sturdy. When used dry, it is excellent for painting exciting textures: mountains, rocks, and trees. You will also paint wonderful branches with this brush.

Paper

Paper, the fourth treasure, was invented in China during the Han Dynasty in 100 A.D. The earliest wood pulp paper was made in Shuen, and that name was given to the most popular paper. I use handmade "Double Shuen" paper, which is thin and absorbent. If you ask for the correct paper to paint flowers and birds, a Chinese supplier will know what you need. The paper is lightly sized with alum on one side and comes in large sheets approximately 27 by 54 inches. Please do not use what is referred to as "practice paper"; it does not receive water in the same way and you'll just be fighting the paper.

Divide each sheet in half crosswise and make a firm crease with your nail. With a brush, place a small amount of water along the crease and the paper will tear quite easily. A torn edge is much more pleasing than a cut one. Next, divide the two halves in the same way to make four sections. Then, instead of dividing them in half again, make a longer sheet and a shorter one as illustrated.

When painting, always place white felt under your paper to absorb the excess moisture. Remember to always paint on the smooth side of the paper. Have two squares of an absorbent paper towel folded up to 5 by 5 1/2 inches placed next to you on your painting side (your right side if right-handed). Use the towel to remove the excess water from your brush.

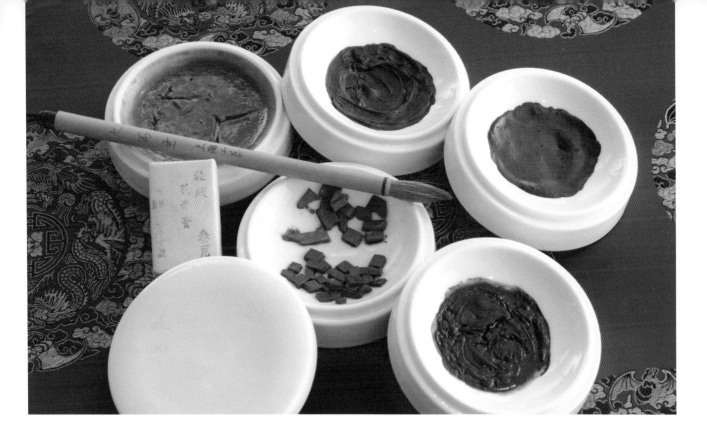

Colors

Chinese colors are made from mineral and vegetable pigments mixed with glue. The only pure Chinese colors that are a must to have are Chinese Rattan Yellow and Vermilion; these are difficult to replicate with Western pigments. Tube watercolors will work perfectly well for all other colors.

If you have Chinese chip colors, place the color chips in a little dish and add a small amount of water. Each color should have its own dish; however, as there are only five dishes in a dish set, I keep Vermilion and Burnt Sienna in the same dish. I simply place Vermilion on one side of the dish, and Burnt Sienna on the other side. There is glue in the chips, so they stick to the dish when the water evaporates.

If your colors are in stacking dishes, always let them air dry before re-stacking.

Brush painting is a watercolor technique that makes full use of the transparent and translucent qualities of the medium. The basic colors you will be using are Chinese Rattan Yellow, Indigo, Burnt Sienna or Raw and Burnt Umber, Rouge, Vermilion, Light Mineral Green, and Mineral Blue. In these lessons I refer to several tube watercolors; when you use them, follow the same methods for use as described in "Color Blending," page 31.

If you are unable to obtain the Chinese colors, you may substitute:

CHINESE COLOR	A SUBSTITUTE
Yellow	Sennelier Indian Yellow
Indigo & Burnt Sienna	Watercolors of same name
Rouge	Alizarin Crimson
Vermilion	Sennelier Chinese Orange and French Vermilion
Light Mineral Green	Sennelier Cobalt Green, add slight amount of Yellow
Light Mineral Blue	Sennelier Cinerous Blue
Red	Any true Red (not too Yellow or Blue)

Chinese Yellow, which is made from solidified rattan sap, comes in chunks. You can use the chunks directly by adding a small amount of water and letting only a portion of the chunk soften; however, for best results, I suggest you place the Yellow chunk in a very small jar and cover it with water. In about two to three days, the Yellow will be liquefied. It helps to take a toothpick and mix the liquid around while the chunk is dissolving, perhaps two to three times a day.

When completely dissolved, pour your Yellow into a small, rimmed dish and let it dry completely (about a week). To use later, simply add a few drops of water and it should reconstitute beautifully. It is very important that you keep your Yellow clean. When painting, always touch the Yellow with a clean brush and not one with color on it.

Note: Except for Chinese Yellow and Vermilion, all colors used for illustrations in this book are Sennelier extra-fine watercolors.

Additional Supplies

You will need two containers for water; the second is to ensure that you have clean water handy. If possible, purchase a divided, three-section water dish, which offers the most convenience for rinsing and guarantees a source of clean water. For mixing your colors, a chrysanthemum or flower palette,

which has separate wells for mixing colors, is recommended. A plain white plate will also work.

Two paperweights may be placed at the top corners of your painting to anchor your work and to prevent the paper from slipping as you paint. Always hold the paper with your free hand.

The Art Table

I hope that you will find a small area to set up your painting equipment and have it at the ready whenever you have a few moments to paint. You will want to use a table that is of the right height so that you can move your arm about without hitting your elbow on the table. Make sure your chair is comfortable and that you sit with the proper posture. This may

sound like kindergarten, but I guarantee that feet flat on the floor and an erect posture will help you greatly. Remember that you are bringing all of your *ch'i,* or life force, to your painting and this is one way to aid your expression. If you feel you would paint better standing, go for it!

All items on the art table are placed on a piece of white felt with the painting paper smooth-side-up.

- Place an absorbent paper towel at the table edge and your blossom palette or mixing plate above the towel.

- Place a divided water bowl or two containers of water above the palette with your brushes and brush rest farther to the outside. It is important that your brushes are always placed there because a brush lying next to the artwork could accidentally mark it.

- If you are right-handed, place all items on the right. If you are left-handed, place all painting items to the left.

- If you have stacking ceramic dishes with color, place the colors you are using alongside your blossom palette and the remainder above your art-work. Place paperweights at the top of your painting.

Key Techniques

There are several basic techniques that, once mastered, will enable you to engage in any subject. To begin, it is important to learn how to hold your brush properly. This will allow you to move in all directions, giving your strokes shape and spirit.

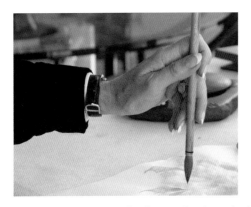

Holding the Brush

The brush is held between the tips or first sections of your thumb and index finger. Your middle finger will be on the same side as your index finger, but below it. The nail of your ring finger is on the same side as your thumb and works as a balance control. Don't worry about the little finger—it will just fend for itself. The palm of your hand should form an egg shape. For more control, hold the brush closer to the hairs; for less, hold it farther up the handle. At first, positioning your fingers this way will feel a little awkward, but I promise you that with diligence in holding the brush in this manner, you'll get delightful results.

The Three Basic Arm Positions

In most physical activities, like tennis, swimming, and running, form is essential to function. Likewise, in Chinese brush painting, even the way you sit is important. This is because concentration is enhanced by your sense of balance, which depends upon the way you sit. To achieve balance while sitting, sit with your feet flat on the floor with your legs uncrossed. Hold your paper with your free hand to further balance the body while holding the paper in place.

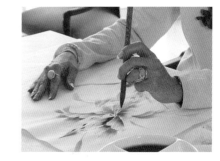

The first position is used for painting with your fingers only with no arm movement. Keep your painting arm down on the table with your wrist and hand up. It is important that you leave some space between your hand

and the paper. Hold the brush so that your fingers are close to the hairs. This arm position, with the fingers properly placed on the brush, will give you excellent control when painting short strokes with hand movement only. For the second position, the hand is held in the same manner as the first, but the arm is allowed to move to accomplish longer strokes.

The third position allows you to work with even more freedom. The arm is kept completely off the table and held parallel to it. Your hand is placed further back on the brush, farther away from the bristles.

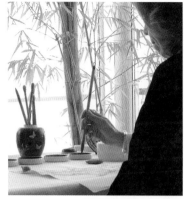

PHOTO BY STEPHEN BOWMAN

The Three Basic Strokes

The three basic strokes in Chinese brush painting are line work, the wipe stroke, and the dot stroke. The brushstrokes lend the painting its unique beauty while depicting the spirit of the subject and the individuality of the artist. Remember, "good practice brings perfection." Practice the strokes accompanying each project until they seem to flow naturally and spontaneously from your hand.

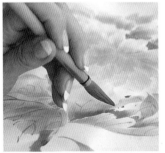

Line Work: When the tip of the brush remains in the center of the stroke, it is called "line work" or "centered brush." To execute this stroke, hold the brush perpendicular to the paper and exert pressure on the tip. Keep in mind that only one-third of the brush is used, thereby limiting the width of the stroke. If you need a wider stroke than a third of the brush will deliver, change to a larger brush.

Wipe Stroke: For the wipe stroke, also called a "side brush" stroke, the brush is held parallel to the paper and the hairs of the brush "wipe" the paper, using the entire length of the brush. The tip of the brush stays on one side of the stroke. This stroke covers a greater area of the paper than a centered brush stroke. A modified wipe stroke (slant stroke) occurs when you hold the brush at a 45-degree angle.

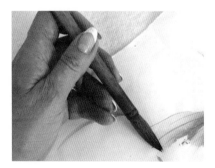

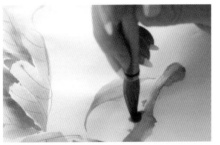

Dot Stroke: For the dot stroke, the brush is held vertically, perpendicular to the paper, and pressure is exerted on the tip in a circular manner. A variation of the dot stroke, a nail head stroke is formed by applying slight pressure, then quickly releasing the tip of the brush.

The width of a stroke is determined by the size of the brush and the amount of pressure exerted on it. As a beginner, always use a small brush for a small stroke and a large brush for a big stroke. The amount of moisture, the degree of pressure exerted on the brush, and the speed of your brushstroke may vary a good deal. Keep in mind that the middle ground is best. Too fast, you may lose control; too slow, your stroke may bleed and show hesitation. Remember, the slower you paint, the drier your brush should be.

Bone Work

BRUSH:
Any hard brush

MOISTURE
Dry

COLOR:
Usually Ink only

Bone work is considered line work, but with the beginning and end of the stroke disguised. The bone stroke is the Mount Everest of Chinese brush painting! It can be difficult to learn, but taking the time to study and practice this stroke will bring great rewards.

The bone stroke is the most elegant of calligraphic strokes. It involves finger movement, changes of direction, arm movement, and a flourish at the end. The bone stroke is used primarily for twigs and branches, and forms the joints of the Bamboo culm (stem). When painting flowers, the blossom is usually painted first, then bone work is used to enhance the flower with strength, power, and solidity. It affords an opportunity to give solid form to your flights of floral fancy.

The Bone Stroke (or "Hiding the Tail")

As in many strokes in Chinese brush painting, the bone stroke begins with an initiation stroke. That is a stroke that starts in one direction but reverses to go back the opposite direction. The initiation stroke is very slight and almost imperceptible, yet very important to remember. There are four ways to do bone work.

Separate Bone Strokes: At the initiation of the bone stroke, the tip of the brush is barely on the paper and pointed toward the upper left (if you're right-handed; toward the upper right if left-handed). Using only your finger-motion, slightly, gently, push the tip up, and immediately bend it down by applying pressure. Then, immediately rotate 90-degrees (counterclockwise if right-handed, clockwise if left), making a circular movement with the brush tip. Establish the pressure and use the movement of your arm to carry the stroke across the paper. The arm movement is from your shoulder, not the elbow.

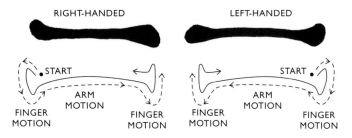

At the end of the stroke, use finger-motion again and (1) pull the tip in a downward motion, (2) immediately turn it 90-degrees to swing up, and (3) flick the tip back into the area that you have already painted, thus camouflaging the point where the brush is lifted off the paper. This is a movement in place called "hiding the tail."

Complete your first bone stroke, then change the angle of the branch by doing a second complete bone stroke, just touching or overlapping the first stroke with a narrow angle between adjacent strokes. Note: This technique is best employed when painting small twigs and stems.

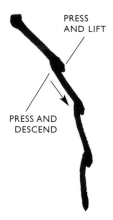

PRESS AND LIFT

PRESS AND DESCEND

Overlapping: Overlap the end of the first stroke with a portion of the next stroke. The second stroke is begun with the lift at the end of the first stroke. This quickly becomes the initiation or lift stroke forming the second section of the branch. To state simply, you omit hiding the tail. The brush is never lifted completely off the paper; simply pause to regroup, and then continue. Overlapping is a complex technique requiring practice, focus, and a thorough understanding of your plan and its execution.

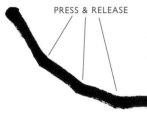

PRESS & RELEASE

Forming Exaggerated Angles: Create a bone aspect by changing the direction in which the tip is facing. That means, keep the tip always in the center of your stroke by holding the brush vertically. Then, when you change the direction of the stem/branch, press down slightly and change the angle/direction of the tip. Release the increased pressure and pull out and away with arm motion. Keep repeating this motion for each joint you paint.

Pressure Only: Pressure-only is used to form joints and is seen primarily in straight vines, stems, or branches. The same principle applies here as in forming exaggerated angles. Initiate the bone stroke in your usual manner by exerting pressure on the brush. Then, without relieving that pressure, turn the brush with finger-motion 90-degrees, and with arm motion pull down to establish the length and width of the branch. Your arm is off the table.

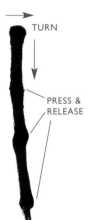

TURN

PRESS & RELEASE

For each successive joint, exert slightly more pressure on the brush, then immediately release this extra pressure and pull down to the next joint. This is a continuous stroke for the entire length of the stem. It is the easiest stroke to master and helps you to understand the other strokes.

Tips for Success

Before you start, it is helpful to use your thumbnail to make an impression on the paper indicating the path of the stem. The indentation will guide you and your stem will find its own happy ending.

Plan: Stop and think, plan, visualize fully, then boldly and confidently set your direction and embark.

Control: The tip of the brush needs to be kept within the center of the stroke and the hairs of the brush should not be allowed to split.

Lifting the Mid-section: Avoid lifting the mid-section of the brush after the width of the stroke has been established. While the size of your brush determines the width of your branch, it's the constant pressure on the mid-section of the brush that maintains the width of the stroke. If you relieve too much pressure and then reestablish the pressure, the branch will have an unnatural aspect. Branches and stems do narrow toward the end, but always with a natural and gradual appearance.

Too Wet: Because you will be working in a slow, deliberate manner in the beginning, it is important to have a drier brush. A dry brush is used to produce a *Fei pai,* or "Flying White" effect, which is a dazzler. The dry brush skips along the surface of the paper, revealing the paper through parts of the stroke.

Warmups: Before you begin your brushwork, it helps to do a few warm-up strokes to help to assure certainty and competence when you proceed with the actual painting.

Color Blending

The translucent colors used in Chinese brush painting provide a delicate counterbalance to the forceful nature of the black ink. The Chinese brush can be loaded with two or three colors at once for variation and richness.

When you begin, rinse your brush several times in clear water to make sure all of the brush hairs are wet. At the same time, it is a good idea to place at least half a teaspoon of water in your Chinese Yellow to soften the paint. Remove the excess water from your brush on the rim of your water container. As you do so, get in the habit of making sure that all of the hairs are straight and that the tip of the brush points directly down from the handle. This is referred to as reshaping the tip. Always reshape your brush before you begin to paint.

Never go directly from undiluted color to your painting. If you do, you risk having too much paint on your brush, causing streaks in your brushstrokes. The paint that you pick up must always be worked into the brush.

Steps for Color Blending

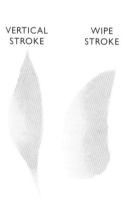

VERTICAL STROKE WIPE STROKE

1. Using only the tip of your brush, scoop up your first color. When painting leaves, this would be Yellow. Holding the brush vertically, move the brush tip back and forth in a lateral motion on your mixing dish. Do this at least four or five times or until you see that the color is fully incorporated into the brush. Do not bend more than one third of the brush hairs as you do this. Reshape the tip against the side of your mixing dish.

2. Scoop up your next color (for leaves this would be Indigo) in the same manner, but this time do not bend more than one fourth of the brush hairs as you work the color in. Use only three or four lateral movements of the brush. Your brush should now be loaded with:

Water at the top

Yellow in the mid-section

Yellow green at the tip

3. Touch the very tip of your brush to your second color (Indigo) again and work in two or three times while you are holding the brush in a vertical manner.

Note: The more you bend your brush as you blend in your colors, the higher up the color will go. Remember to keep a clear water base in the upper-third of your brush.

Your brush will now contain:

Water at the top

Yellow in the upper mid-section

Yellow green in the lower mid-section

Dark green at the tip

All color blending is done in this manner. After practicing this brush loading technique, you will be able to make a smooth transition from color to color.

Moisture Control

Before you begin to paint, be sure that the brush hairs are completely saturated with water. This is not a matter of just dipping the brush once into water. Rather, swim the brush back and forth until you are certain that all of the short, hidden hairs are completely saturated. This thorough soaking needs only to be done at the start of your painting session. Remove any excess water on the rim of the water dish before mixing color.

I suggest that you start with what may seem to be a very dry brush. It is better to have your brush too dry rather than too wet. As you progress, you can always adjust the amount of moisture in your brush. Remember, the slower you paint, the drier your brush must be. Check often to see whether your brush has too much moisture by tapping it lightly on a paper towel.

As you do so, make sure that the brush is parallel to the paper and that the hairs are aligned and not twisted.

There are three terms regarding moisture control that will be referred to in this book: dry, medium, and wet.

If you see that your brush contains too much moisture, lightly dry the very tip before adding the next color.

Dry Brush: A dry brush is one that has all the discernable moisture removed from it. Always begin with your brush completely saturated with water. Load the brush with color as required, then remove the excess moisture on your dish. Next, remove even more moisture by repeatedly stroking the full length of the brush hairs across an absorbent paper towel, taking care not to disturb the straight alignment of the hairs. You may then pick up a slight amount of color tone on the very tip of your brush. This dry brush is most important for detail work.

When doing a larger stroke and a dry brush is indicated, gently stroke the brush on your towel, leaving slightly more moisture in the body of the brush. Remember, you can always force some moisture out of your brush when painting, but there is no escape from a too wet brush. That is the hardest lesson to learn.

Medium Brush: For a brush with medium moisture, remove the excess moisture on your mixing dish, reshaping the tip as you do so. Then, holding your brush horizontally, gently tap the brush on your paper towel until the desired level of moisture is achieved.

Wet Brush: A wet brush is fully loaded. Reshape your brush on the mixing dish, removing the excess moisture while doing so. There is no need for the paper towel.

Moisture Control with Ink

Something to bear in mind when using Ink: The more water in your brush, the more the Ink will spread. Therefore, after removing all of the water from your brush, fully load it with Ink. Then, remove the excess Ink on the rim of your dish and dry the brush again on the paper towel. Now the brush is ready to load with Ink and you may begin painting. The additional drying of the brush assures that most of the water has been removed; the wet brush is all Ink.

When using lighter shades of Ink, made by adding water, you will need to paint faster and have a drier brush. Experiment before painting on your masterpiece.

Leaves

Leaves are as important in Chinese floral painting as clothes are to the human form. And, like clothes, they are there for more than convenience, protection, or mere adornment. Indeed, in art as in nature, leaves enhance the primary subject and are crucially important in achieving a balance of artistic design. The placement of leaves—their tone, texture, size, and shape—is to be regarded thoughtfully in the composition, as they are a part of the very heart and soul of it.

Do not try to achieve symmetry with leaves; do not center them or distribute them equally or uniformly within the composition. That is not what is meant by balance in design. Rather, aim for harmony, not symmetry. Harmonize the weight—the values and elements—of your leaves with the weight and values of the subject as a whole. While painting, keep in mind the respective elements, as they relate to and coordinate with one another.

The artist's goal is to spontaneously coordinate the parts of a composition, just as all of the elements of heaven and earth move in rhythm with the universe. Coordination here becomes an artistic and mystical exercise of letting the mind and soul fly free to produce one harmonious creative expression—that expression flowing spontaneously from your heart and soul.

One way to achieve harmony is to allow the weight or visible substance to appear to be growing either to the right or left side of your composition, or growing at the bottom or top. The leaves may be unevenly scattered throughout the painting, and, for added interest, you may cluster, bunch together, overlap, or intertwine them. Please remember to leave at least one-fourth of your painting blank; honor the void and you will be rewarded. Conceive of every thought and movement first with your heart and soul, then, with your brush, let your inner impression become your visible expression.

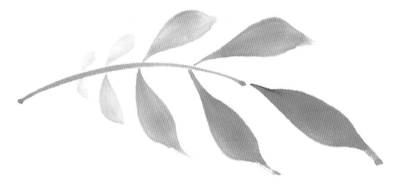

Painting Leaves

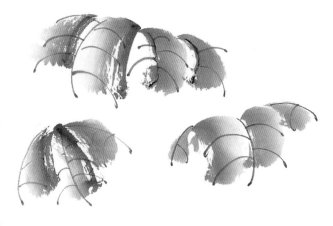

Tone: Light values will cause some leaves to be darker than others. Variety in color tone (in addition to hue and shading) is essential for interest, so utilize light and dark contrasts. Have dark leaves appear to cross or actually cross over lighter leaves and stems. Remember that younger leaves are generally lighter and richer in tone. This could involve introducing, for example, a Yellow Green to complement a darker shade. Often the underside of a leaf is darker than the top. To indicate this darker-tone, touch the tip of your brush again to Indigo or Neutral Tint, then to Alizarin Crimson for the final color; work this in slightly.

Texture: To add vitality and rough texture to your leaves, you may use *fei pai* or "Flying White." To do this, work with a very dry brush and skip the color along the surface to reveal white paper through parts of the paint.

When painting fully-formed, mature leaves, remember that some will be turning slightly brown, some will be partially eaten by insects, and some will be torn by wind, rain, or animals. Leaves at the bottom of the stem or plant may be done in a faded color such as Green mixed with Burnt Sienna or with Neutral Tint lightened with water. Paint these in a rough, loose manner.

Before painting leaves, refer to the section on Color Blending on page 31 and aim at having more than one color or tone on your brush.

Size: Consider the size of the leaves in relation to the primary plant or flower. Vary the size of your leaves, keeping in mind the Host/Guest relationship: the host would be the primary flower, and the guests would be the supporting, smaller flowers. Add small, young leaves for excitement. Remember, the size of your brush determines the size of the leaf.

Shape: The shape of the leaf is primarily determined by the species of plant; however, there are other factors to consider. For example, in planning and painting shapes, consider turning leaves; leaves that are partially hidden from

view; leaves that are not fully formed; and, leaves that are distorted, for example by age and insects. Leaves may be curled or fully unfolded, that is, fully extended. Also, sun and wind direction makes a difference in appearance. Although a light source is never considered in Chinese brush painting, your composition will have more grace and rhythm if the leaves lean in the same general direction, appearing as if they are gently swaying in the breeze.

In your painting, all these characteristics of shape are determined mainly by two factors: (1) the angle at which you hold your brush; (2) the amount of pressure you apply to the brush. Shape also relates, of course, to size. If you paint two or more strokes to enlarge a leaf, make the second stroke somewhat shorter. Paint wet on wet for proper blending.

The Basic Leaf in the Vertical Manner

The size of the leaf is determined significantly by the brush you use and by the amount of pressure you apply. Start with no pressure, then apply pressure, and then release the pressure.

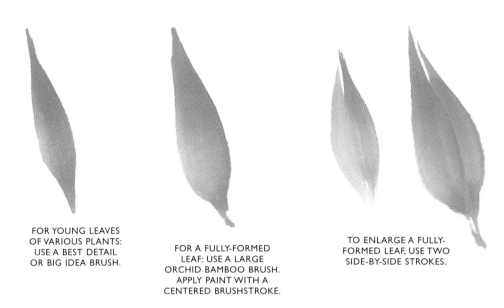

FOR YOUNG LEAVES OF VARIOUS PLANTS: USE A BEST DETAIL OR BIG IDEA BRUSH.

FOR A FULLY-FORMED LEAF: USE A LARGE ORCHID BAMBOO BRUSH. APPLY PAINT WITH A CENTERED BRUSHSTROKE.

TO ENLARGE A FULLY-FORMED LEAF, USE TWO SIDE-BY-SIDE STROKES.

The Basic Leaf in the Wipe Manner

Using a wipe stroke is another method for painting leaves. To begin, hold the brush at about a 45-degree angle and place the tip. Bend the brush and hold it parallel to the paper. Apply pressure so more of the brush is in contact with the paper, and pull the brush down the paper. As you move the brush, the tip paints one outer edge of the leaf, the body forms the wider portion of the leaf, while the heel forms the other side of the leaf.

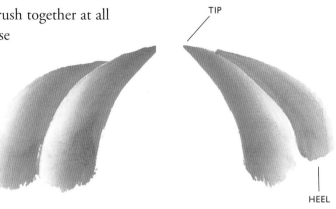

TIP

Be sure to keep the tip of the brush together at all times. A split tip will cause you to lose control of the stroke. To end the stroke, flick the tip back up toward the middle of the stroke and lift rapidly. This will prevent a water spot. This basic wipe stroke is usually done two times to form a mature leaf; use one stroke to paint young leaves.

HEEL

Painting Veins

All vein work should be done very quickly and in a casual manner with the tip of a dry Best Detail brush. Use a modified bone stroke or "nail head" (see page 28): apply pressure, then release the pressure as you arch the vein across the leaf. With experience you will find that a slight hesitation at the end of the stroke is elegant. If preferred, you may also do a little hook at the end of the stroke.

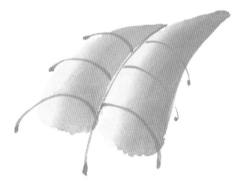

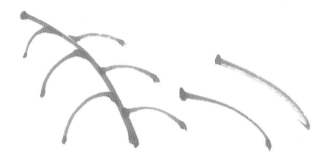

When veining leaves, be sure your brush is very dry and the leaves are barely damp. If you paint veins on leaves that have dried, the strokes will appear pasted on.

Turning Leaves

1. The first stroke you make must have a disappearing edge.

2. The second stroke must have a straight edge that, when combined with the first stroke, forms a V-shape on the top of the leaf.

3. Sight the location for the line of the leaf as it turns. At this location, originate the stroke to paint the underside of the leaf. Strokes 1 and 2 are the same color. The stroke underneath is darker.

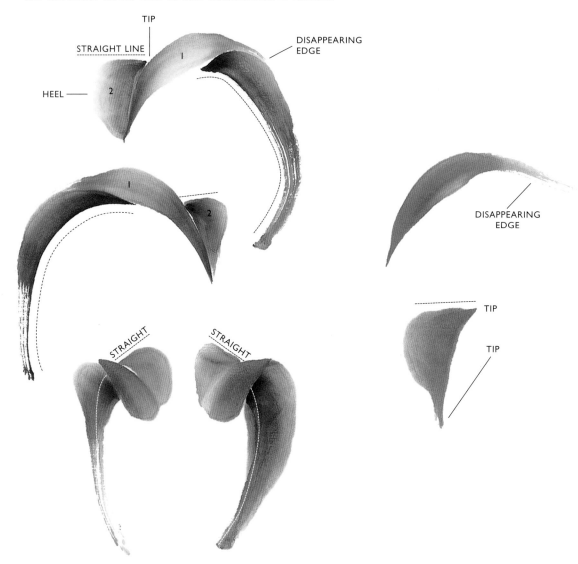

Sometimes something just does not work out. Sound familiar? When you have a real 'oops,' it's an opportunity to experiment and actually save the day. First, in order to preserve some of the original color tone and brushwork, try not to rework the area too much. Another hint, if you have, perish the thought, a mistake (really there are none) then just do it again somewhere in your painting and you have *style!* Relax, have fun, and enjoy the unexpected.

Part Two
Enchanting
Flowers

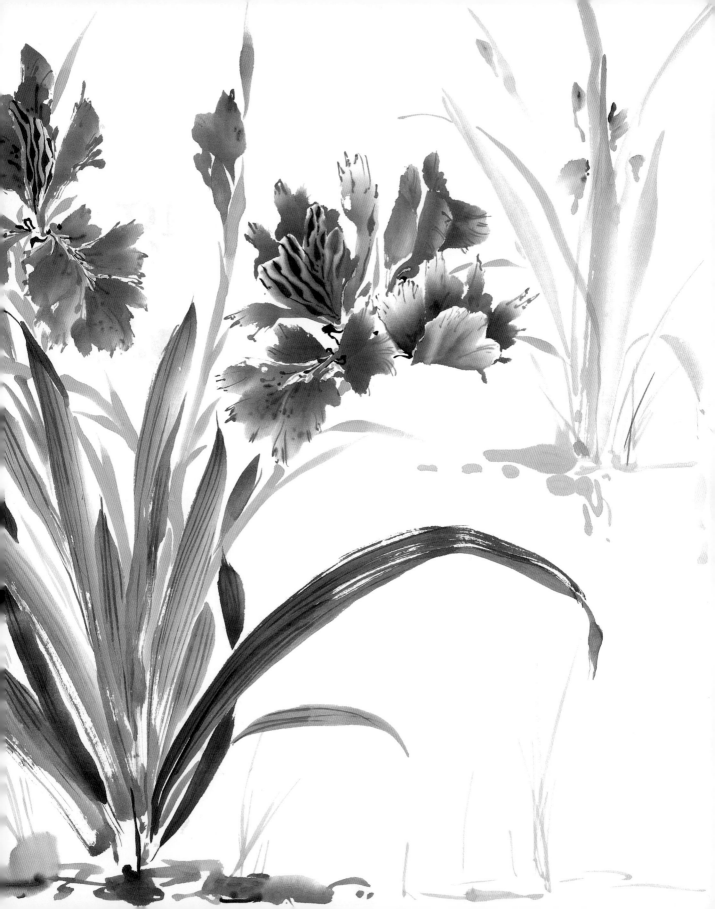

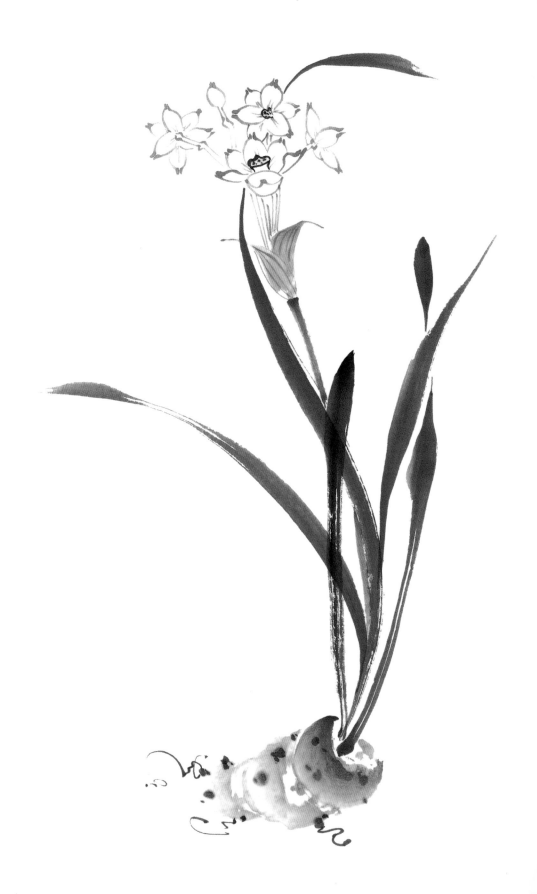

Narcissus

Symbol of Endurance

It is no wonder this elegant flower is named Narcissus. From the ballerina-like leaves to the delicate, perfumed blossoms, everything is a marvel of perfection and captivating beauty. Even the bulb has character and interest! Due to the purity of its blossoms and subtlety of its fragrance, the Narcissus is a metaphor for the high ideals of the gentlemen scholars. Admired for blooming during the cold days of early spring, the Narcissus is a symbol of endurance in difficult times.

The Flowers

Painting the Narcissus is an exercise in sweeping freedom, along with elegant restraint. There is a cluster of small flowers radiating from a single stem and it is there we shall begin. The flowers are painted in the contour/outline manner.

BRUSH:
Best Detail

MOISTURE:
Very dry

COLOR:
A reservoir of light to medium tone Neutral Tint or Ink

Paint up to eight flowers and aim at including as many views as possible. In the illustration you see a full flower, a foreshortened flower, a back view, a side view, and a bud.

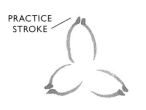

PRACTICE STROKE

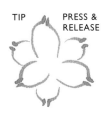

TIP PRESS & RELEASE

There are six petals on each flower segment. To form each petal, exert a slight amount of pressure on the tip of the brush, and then ease up on the pressure as the stroke is completed. Because this is line work, the brush is held perpendicular to the

43

paper. Paint three full petals as indicated, then paint the three partially hidden petals. Using the tip of your Best Detail brush, add a slightly deeper tone and paint the center of the flowers. Once dry, fill in the visible centers with strong Yellow, and when this is barely damp, add pollen dots in Ink.

The Sheath

BRUSH:
Big Idea

MOISTURE:
Dry to medium

COLOR:
A pale tone Burnt Sienna tipped to Neutral Tint

Leave a space between the flowers and sheath. The sheath is basically a small leaf stroke. Begin with no pressure on the brush, press down slightly as the brush travels, and then release pressure at the point where it will meet the stem. While the sheath is still damp, place several lines along the sheath, as shown, using a dry Detail brush and a medium tone of Neutral Tint.

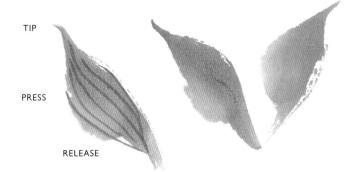

TIP

PRESS

RELEASE

Because the sheaths are very thin and eventually fall away, be sure to use a pale tone and a more relaxed manner.

The Leaves

TIP

The leaves are your opportunity to create an exciting, lively composition using a minimum of strokes. It helps to use your thumbnail to lightly indent the desired path on the paper. The leaves do not need to be uniform in width, but it is important to have all of the leaves meeting the bulb and forming a V-shape for maximum elegance.

BRUSH:
Big Idea

MOISTURE:
Medium

COLOR:
A reservoir of Phthalo Green or Hookers Green mixed with Lamp Black. Use more Black than Green. Be sure to have enough color to paint all of the leaves before beginning.

When painting elongated leaves, you may either start at the base of the leaf and drag the brush upward, or start at the end of the leaf and pull the brush downward. This is a vertical stroke that

begins with a slight amount of pressure. Maintain the pressure, varying it slightly until you reach the area of the bulb. Paint freely and create a slight arch as the brush travels. If the tip of your brush lifts off the paper before you finish the stroke, do not try to reconnect the leaf at the same point. Rather, start the stroke again at least one-quarter inch away and the viewer's eye will fill in the space.

The Stem

Your painting will be more interesting if you break the path of the stem with a leaf. However, do not have more than two breaks. To paint the stem, first establish the width of the stroke with a slight amount of pressure on the tip of the brush and then ease up somewhat on the pressure as you descend. Keep the width of the stroke uniform as you complete the stem. Then, to indicate stems for the individual flowers, paint a series of lines using the flower reservoir.

BRUSH:
Best Detail

MOISTURE:
Dry

COLOR:
Yellow Green

The Bulb

BRUSH:
Big Idea

MOISTURE:
Dry

COLOR:
Pale tone Burnt Sienna tipped to Neutral Tint

When you rinse your Big Idea brush after painting the leaves, leave a slight amount of color in the heel of the brush. That is, rinse the brush well but not completely. Then tip the brush to Burnt Sienna, work it in, then tip to a darker tone, such as Neutral Tint, and work in slightly.

To form the bulb, do three wipe strokes with the brush held almost parallel to the paper. Make each stroke smaller than the last by putting less pressure on the brush. You will need to practice getting color variations in these strokes. Keep your brush very dry to obtain the bold and interesting look of the bulb. To finish, draw a few roots and place random dots as indicated in the illustration on page 42.

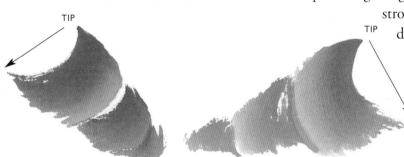

TIP

TIP

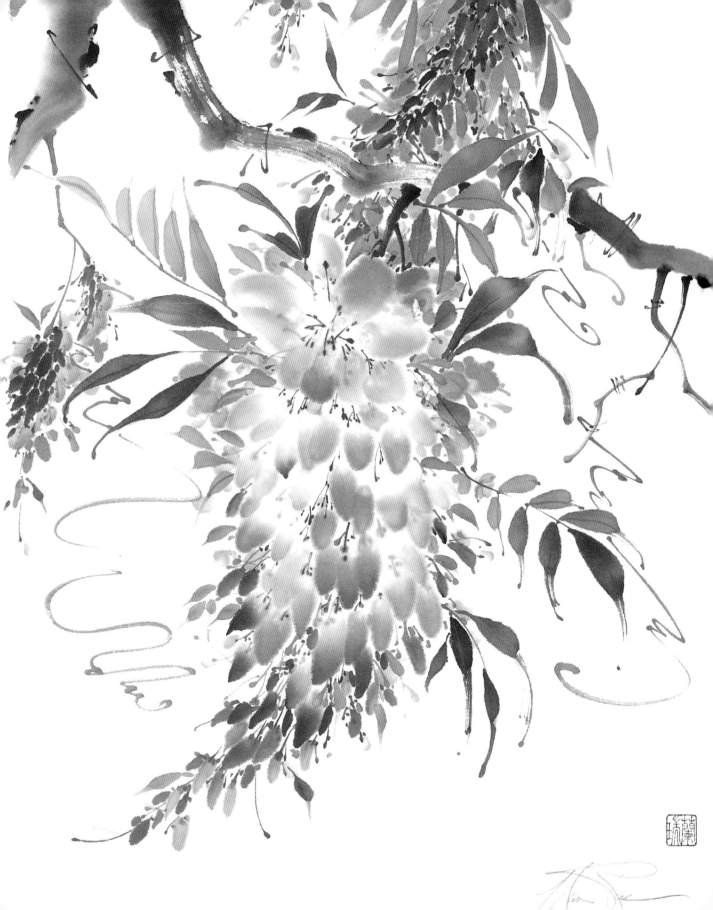

Wisteria

Cascading Beauty

Just hearing the word "Wisteria" makes one think of delicate daydreams. It is a wisp of a flower that captures your imagination. So complex is this wonder, that rather than attempt to portray its all too fleeting beauty, let us aim instead to capture its essence.

Chinese Wisteria is Violet Blue; Japanese Wisteria is White and Purplish-Blue. There are also Mauve and Rose Wisteria. In all colors, the contrast between the dreamy delicacy of the blossoms and the gnarled, twisted vines is especially captivating.

Preparing Your Palette

The preparation of your palette is the single most important step taken when painting the ethereal Wisteria blossoms. This crucial preparation must be done thoroughly and properly so that there will be no impediment to your painting. All colors to be used must be at the ready before you begin painting. Your mixing palette should include the following:

1. A deep tone of Purple. This can be made by combining equal amounts of Indigo and Alizarin Crimson or Crimson Lake. Mix the two together with a small brush and wipe the excess from the brush into a second well on your palette. Add enough water to this second color well of Purple to make a reservoir of very pale Purple. Test the color on a piece of paper to determine if it is light enough.

 Note: If your prefer, instead of mixing your Purple, use Cobalt Violet Deep Hue.

COLORS
You may use any of the color combinations listed for painting the petals. Just remember to use the same color plan throughout the painting.

FLOWERS:
Alizarin Crimson / tip to Indigo
A combination of Alizarin Crimson and Indigo
Cobalt Violet Deep Hue
Cerulean Blue and Cobalt Violet
Purple Magenta / tip to Neutral Tint
Neutral Tint only

LEAVES:
Yellow-Green

BRANCHES AND VINES:
Ink only or Burnt Sienna tipped to Neutral Tint.

2. White. Pelikan White in a tube is excellent. White is seldom used in Chinese brush painting, as it diminishes the transparent nature of watercolors. We will only use it in the very center of our fully opened Wisteria blossom.

3. Yellow. Place a few drops of water in your Yellow color dish before beginning to set up. Once it has softened, scoop up a brushful and place it in a well on your palette.

4. Two tones of Green. A Yellow-Green and a deep Green made by combining more Indigo than Yellow in the well.

 After you have mixed all of your colors, rinse your brush and get some clean water. You are ready to begin.

BRUSH:
Large Orchid Bamboo

MOISTURE:
Wet

COLOR:
See above

Fully Opened Petals

Since the upper petals are the first to bloom, paint the pale, fully opened petals at the top and mid-section first, then the deeper, unopened blossoms at the bottom. The paler the tone used to paint the open petals, the lovelier and more delicate your Wisteria will look.

Rinse your Large Orchid Bamboo brush completely in clear water and reshape the brush tip on the rim of the water container. Gently remove some of the moisture by touching the very tip of the brush to a paper towel. Touch only the tip of your brush to the prepared pale purple tone, then, using a clean well, work the color in slightly while holding the brush vertically. Remove the excess moisture on the rim of your palette. If there is too much moisture in your brush, lightly touch the brush hairs to a paper towel, holding the brush horizontally. Do not twist the brush hairs on the towel, as they must always be aligned in a straight manner.

TIP

TIP

Paint the top cluster of petals in a counterclockwise manner (if you are left-handed, paint in a clockwise manner). For each stroke, place the brush parallel to the paper and wipe around, using the full length of the brush and dragging the tip to form a semicircle. The heel of the brush remains almost stationary. With enough moisture in your brush, you can accomplish two or three strokes in this manner. Reload the

HEEL

brush if it becomes too dry. Do not make these strokes too even, or the petals will look like a daisy.

When the brush is very dry, the tip skips along the paper, leaving blank spots (referred to as "Flying White"). You can accomplish this by working rapidly. After you have completed the basic circular shape, place a few petals around the perimeter for a more interesting shape.

Using the tip of a small Best Detail brush and White, place random dots and lines in the center of the blossom. When doing this line work, hold the brush in a vertical manner. The White adds moisture to the center and connects the center with the individual petals. When doing all of the line work in the center of the open petals, curve the strokes slightly and try to get a little hook at the end of the strokes. These are done in a rapid manner.

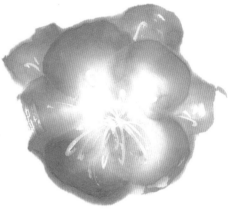

For the remaining line work, your brush should be fairly dry. Without rinsing the White from your brush, pick up a small amount of creamy Yellow and work it into the brush. Place random marks in the center of the blossom. Again, without rinsing your brush, pick up some Yellow Green and repeat the strokes, this time making them somewhat thinner by using only the very tip of your brush. Rinse your brush.

BEGIN STROKES
IN CENTER OF
CLUSTER

Continue the line work, now working with the deepest Green tone, making a few random dots and squiggles. Complete the center with a few small dots and lines of Neutral Tint.

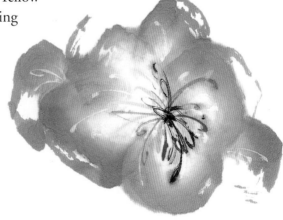

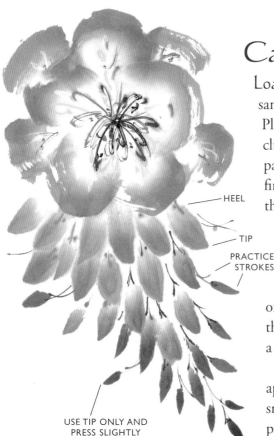

HEEL

TIP

PRACTICE
STROKES

USE TIP ONLY AND
PRESS SLIGHTLY

Cascading Petals

Load your Large Orchid Bamboo brush in the same manner as when painting the opened petals. Place the brush tip a brush length below the main cluster and pointed toward you. Hold the brush parallel to the paper. Place the tip on the paper first, then press the full length of the brush onto the paper and lift straight up.

Paint four or five more strokes in this way, so that they appear like a skirt under the main blossom. Next, paint a row of strokes under the first, but slightly deepen the tone at the tip of the brush and place fewer strokes. As you paint the next row of petals, use a smaller brush, such as a Big Idea brush.

As the petals descend, place the rows farther apart to allow for stem placement. To paint the smallest petals use only the very tip of your brush, pressing down as before and then quickly lifting up. Use the premixed deep Purple with less moisture in your brush.

The width of the Wisteria narrows as the partially opened and unopened petals descend. Wisteria clusters are light and delicate, and a gentle breeze will cause them to sway gracefully. When completing the petal cluster, aim for a graceful curve. This will give your painting a lovely aspect.

BRUSH:
Best Detail

MOISTURE:
Dry

COLOR:
Blue Green

Petal Stems

Using the tip of your Best Detail brush, place connecting lines to indicate stems between each layer of petals. Each line should have a graceful curve and end with slight pressure to form a little nodule. Check to see that all of the petals are connected. A few stems may be added to the sides to indicate that petals have fallen off.

The Leaves

BRUSH:
Large Orchid Bamboo brush

MOISTURE:
Medium to wet

COLOR:
Load your brush with Yellow, Yellow Green, and deep Green (see Color Blending, page 31). If you use tube color, use Sap Green.

First, create the leaf stem using only the very tip of your Best Detail brush kept on the dry side. Hold your brush vertically and make a graceful curve. For the leaves, hold your brush vertically and begin with the leaf at the end of the stem. Start at the stem with no pressure, then press down on one-third of the brush as the brush travels. As the brush continues moving, release the pressure, allowing the very tip of the brush to finish the stroke and gently form the tip of the leaf. The tip of the brush always remains in the center of the stroke.

RELEASE PRESSURE

PRESSURE

START WITH NO PRESSURE

Repeat the stroke to form leaves on both sides of the stem. Use less pressure on the brush as the leaves decrease in size going up the stem. You may be able to complete all of the leaves on the stem with one brush loading. If not, when you reload, make certain the color matches the previous strokes. Note in the illustration, how the darkest Green, which was strong at the beginning, became paler as the brush color was spent, adding a lovely sense of depth to the leaves.

The size of the leaf is determined by the brush you use and the amount of pressure you apply.

To paint young leaves, use your Best Detail brush with dry to medium moisture. Load your brush with Yellow Green only. Again, begin with no pressure, apply pressure, and then release. Use just the tip of your brush.

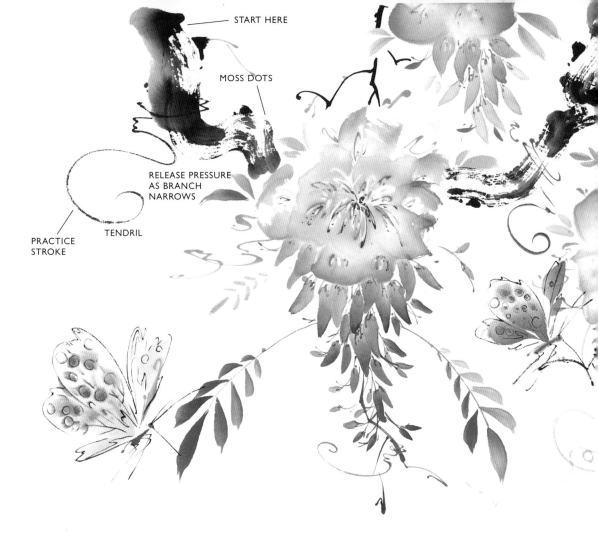

START HERE

MOSS DOTS

RELEASE PRESSURE
AS BRANCH
NARROWS

PRACTICE
STROKE

TENDRIL

Gnarled, twisted, and intertwining, the vines/branches add strength, character, and interest in contrast to the delicate blossoms. They can twist and braid around themselves, and form intriguing, marvelous designs.

Paint the branches with a Basic Soft brush, or, for more texture, use a Mountain Horse brush. Use Ink for the most contrast, or use Burnt Sienna tipped with Neutral Tint. Be sure the brush is very dry and use the side of the brush to execute a wipe stroke (see page 27). Hold the brush parallel to the paper and press down on one- to two-thirds of the brush length. The more pressure you exert on the brush, the wider your stroke will be. As you drag the brush across the paper, change directions without easing up on the amount of pressure being applied to the brush. Ease up on the pressure to narrow the branch. When you get to the end of the stroke, pause for a moment and pull the brush back into the direction you came from (this is called "hiding the tail," which is discussed further on page 28).

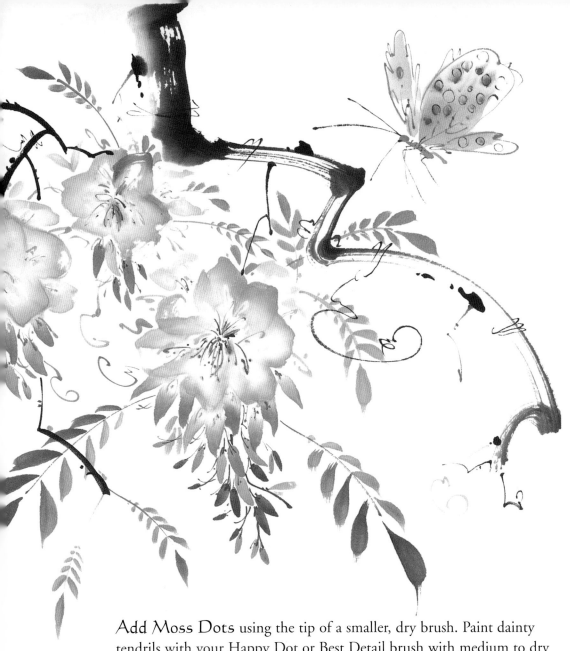

Add Moss Dots using the tip of a smaller, dry brush. Paint dainty tendrils with your Happy Dot or Best Detail brush with medium to dry moisture. Hold the brush mid-point on the handle and use only the tip of the brush.

To finish, add a few well-placed leaves around your main blossoms and have some pale, watery petal strokes, done rapidly, at the top of your painting. Make sure all the elements are connected; you don't want a blossom or petal just dangling in space. Remember to leave at least one-third of your paper blank. This void creates its own interesting shapes.

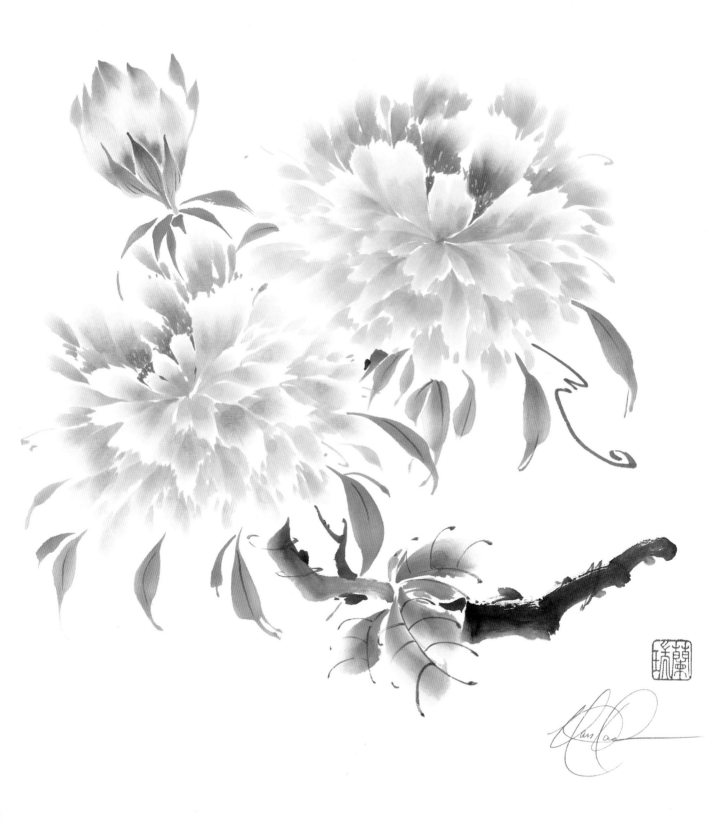

Peony

Symbol of Longevity

In China, the Peony was known as the "King of all Flowers" and it is the epitome of saucy nobility. During the Tang Dynasty (618–906 A.D.), emperors actually placed Peonies under their royal protection. This explains why we see the Peony painted so often, especially during the Ming Dynasty (1368–1644), when the Peony truly blossomed on ceramics.

The Peony is magnificent in appearance and complex in its structure. This study introduces you to the royalty of the Peony's effulgent beauty.

The Blossom

The Peony is wider than tall and can have as many as 500 petals. As you paint these petals, keep in mind the somewhat oval shape of the flower and aim at achieving balance.

Make a reservoir of a pale tone color, enough to complete the entire blossom. Begin with the back side of the inside front petal; it is flat and short. Work rapidly because your brush will be fairly wet.

BRUSH:
Large Orchid Bamboo. For smaller petals, change to a Big Idea brush.

MOISTURE:
Medium to wet

COLOR:
Your choice. Suggestions are Yellow, any Pink, Purple, or Deep Crimson. The flower shown on the following pages was painted with Alizarin Crimson. The flower on page 54 was painted with Yellow tipped to Vermilion.

Touch just the tip of your brush to your reservoir and remove the excess on the rim of your mixing dish. Lightly tap your brush on the paper towel. Do not work the color up into the brush; you want to keep a water base at the upper portion of the brush.

Hold the brush parallel to the paper with the tip pointed toward you. Place the brush flat on the paper to form the center petal. Enlarge the stroke by making two, somewhat shorter, overlapping side strokes, pressing down less on the brush. For all three strokes, the tip of the brush is stationary and only the heel of the brush is moved. As you paint the petals, rinse your brush and reload as soon as you see that the clear water base in the heel has disappeared.

HEEL HEEL HEEL

TIP

The middle of the flower is a cup shape, indicated with additional strokes. Initiate these strokes alongside but one-third higher than the center petals. Push the brush heel upward and lift straight up from the paper. Let the tip follow the heel but stay below it. This technique gives a rounded petal edge and prevents the stronger tip color from traveling too high.

5 4 2 1 3 6 7

START HERE
TO PLACE
THE STROKE
HIGHER

Next, paint the layers or "skirts" below the cup. When painting skirts, the tip is always pointed away from you. For each petal, paint three to five overlapping strokes in a rapid manner. Do the center, longest stroke first, then paint the side strokes. Again, pivot off of the tip and land the heel first in the center and then to both sides.

Remember, the tip of your brush must always point to the center of the blossom to give the appearance of connecting. Add a touch more water to your reservoir so that the color is lighter as you move away from the center.

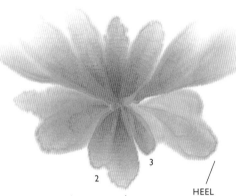

2 3
1
HEEL

For the upper portion of the flower, intensify the tip color, then re-tip to a stronger color for contrast. For example, in the illustration here the base color is Alizarin Crimson. Re-tip to Alizarin Crimson to intensify the color, then tip to Indigo. If your flower is Yellow, tip to Vermilion and then Chinese Red. For a Yellow flower, you may lightly tip your brush to Vermilion when painting all of the petals. Remember to always work in the color you have tipped to.

Insert the tip of the brush into the empty areas at the top of the flower. Drag the tip sideways and press the heel, alternating the pressure to vary the height of the strokes. Turn the heel of the brush toward the center of the area to give an embracing aspect to the petals.

TIP DRAGGED ALONG HERE FOR UPPER PORTION

THREE LAYERS
OF SKIRTS

ADDITIONAL
SMALLER STROKES
ADD VITALITY AND
A SENSE OF *CH'I*

When the central area is barely damp, use the tip of a dry Best Detail brush and thick Yellow Green to indicate the pistil area. For interest, have areas of pistil color peeking through the petals.

While the painting is still damp, place random pollen dots above and in the pistil area with a Best Detail brush and very thick White mixed with Yellow. Be sure your brush is as dry as possible. You may indicate the dots with a comma-like stroke, or paint them with just the tip of your brush touching the paper and quickly lifting off. Remember these, too, are in an attitude of embrace. The dots in the flower are like the pupil of the eye—they are the focal point and life spirit of the flower.

The Buds

Paint the calyx with a light Green tipped to Alizarin Crimson. This is the familiar no pressure, pressure, release pressure stroke. Vein the calyx in Alizarin Crimson. Wait until the calyx is barely damp, then paint light arching strokes using only the very tip of a very dry Best Detail brush. Do this in a rapid, free manner.

TIP

PRESS

RELEASE

BRUSH:
Big Idea
MOISTURE:
Dry
COLOR:
Medium Green for the calyx and your flower color for the bud itself.

Lightly rinse your brush, leaving a little Green in the heel. For a yellow bud, work Yellow into your brush and touch the tip to Vermilion. For a pink bud, use Alizarin Crimson instead of Yellow and touch the tip to Indigo. Place the tip of the brush above the calyx and land the heel halfway to the calyx. Do this three to five times to form the bud. Next, with the brush now pointing towards you, insert the tip into the calyx sections and press the heel back into the mid-section. When painting the bottom of the bud, your brush tip should be dry and stay at least an eighth of an inch from the calyx to avoid bleeding.

TIP
HEEL

HEEL
TIP

Peony 57

The Leaves

BRUSH:
Large Orchid Bamboo

MOISTURE:
Medium

COLOR:
Green

The leaves under the flower itself always bend downward. They are done in a medium tone Green. Touch the tip of your brush to Alizarin Crimson and work in slightly. Place pressure on the tip and then swing out in an arching stroke as you release the pressure. Paint the veins with a very dry Best Detail brush while the leaves are still damp.

Painting the leaves will become very rhythmic after you understand the basic technique involved in the *Mo Ku* (without outline) style, which is spontaneous and free.

Method 1: For the leaves directly under the flower, use a centered brush (Large Orchid Bamboo) held in the vertical manner. Start with the tip of the brush and press down as you travel along the paper. Gradually release the pressure to narrow the ending point.

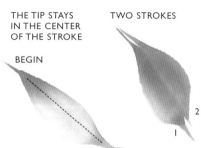

THE TIP STAYS IN THE CENTER OF THE STROKE

BEGIN

TWO STROKES

Method 2: While holding the brush at about a 45-degree angle, begin with no pressure on the brush tip, and then apply pressure by bending down on the brush as you pull the brush across the paper. As you move the tip, it paints the outer edge of the leaf while the body of the brush forms the wider portion of the leaf. You are executing a wipe stroke (see pages 27 and 37). This basic wipe stroke is done at least twice to form a mature leaf. Young leaves are done with one stroke.

The Veins

The veins are done with a Happy Dot or Best Detail brush in Alizarin Crimson or Green. Expressing veins in leaves is easy if you remember to have your strokes arch outward. Start with a little pressure at the center vein and swing outward. A little hesitation at the end of the stroke is all the better. If veining lands outside the original shape, it will add even more excitement to your painting.

The Stem

The main stem is woody, gnarled, and twisted, yet it must appear buoyant, bearing up the "Royal Flower" with the beauty of gossamer and the strength of oak. Use a diluted Burnt Sienna with the tip of your Big Idea brush touched to Ink or Neutral Tint. All stem work is done using a bone stroke. Remember to have at least one leaf that breaks the path of the stem and don't forget to place a few moss dots along the stem for added interest.

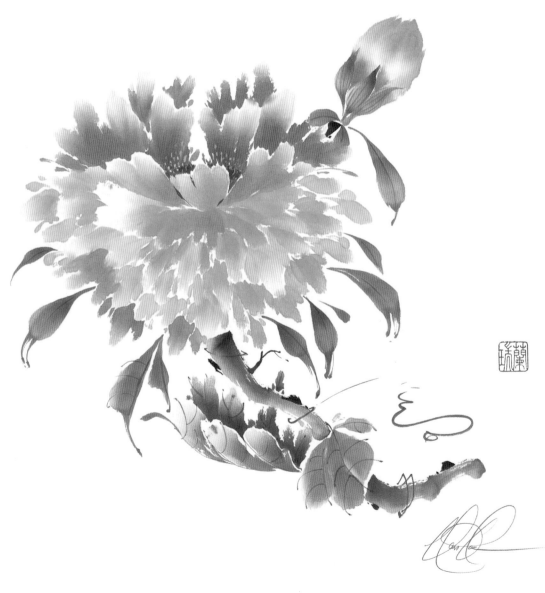

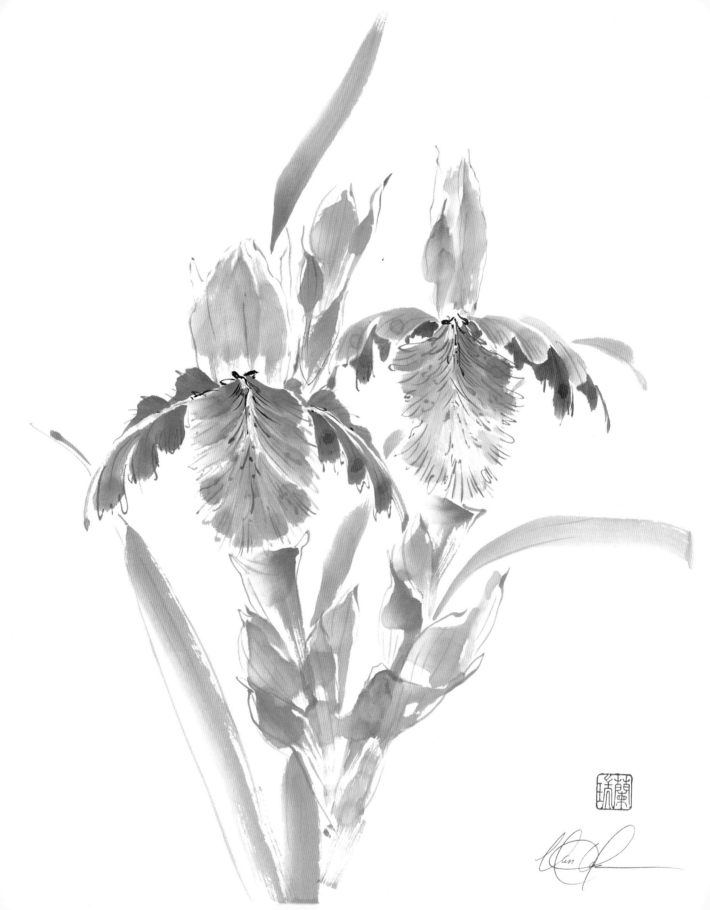

Bearded Iris

Beautiful Butterflies

With all brush painting, the goal is to capture the essence of the subject. The brush painter never has a model. Instead, he expresses the image that is in his heart and mind.

It's time to dream of butterflies as typified by a most delicate and sensitive flower—the enrapturing Bearded Iris. And what a butterfly the Iris is—can't you just visualize it fluttering and dancing in the pure sunlight? Beautiful butterfly, a princess of the floral kingdom, kissed by the breeze, caressed by the sun, and giving grace to the day.

If you permit, your Iris will help you enjoy the vitality and excitement of your brushwork. Please don't approach this beautiful blossom with apprehension or too much careful-ness—throw caution to the wind. Paint with abandon, giving energy and vitality free reign.

With the Iris, we will be painting wet-on-wet. Your brush will be wet and your brushwork rapid and daring.

With Irises, there are many variations of petal coloration:

Self: When all the petals are the same color.
Bicolor: Different colors for the ascending and dropping petals.
Amoena: White top and colored bottom.
Bitone: The same color but different shades for the top and bottom.

There are many possible colors for the petals; I have even seen Russet Brown. Here are suggestions for a Purple or Blue Iris: Cobalt Violet; Cobalt Violet and Indigo; Cobalt Violet, Indigo and Neutral Tint; any combination of Blues or Purples; Ultramarine Light tipped to Indigo; Cobalt Violet tipped to Neutral Tint; Indigo with Neutral Tint at tip; and Neutral Tint.

BRUSH:
Large Orchid Bamboo

MOISTURE:
Wet

COLOR:
Your choice. The colors used in my illustration are Cobalt Violet Deep Hue for the reservoir with Neutral Tint at the tip and Neutral Tint for the detailing.

The Petals

There are three dropping petals that are called "falls," and three ascending petals called "standards." The term "bearded" comes from the Yellow pollen hairs on the upper portion of the falls.

Make a reservoir of pale color. Load your brush from this reservoir and remove the excess from the tip. Touch the tip to stronger color and blend 4-5 times. Repeat by touching the tip to stronger color and blending 3-4 times. And again, touch the tip to the strongest color and blend 2 times. You may wish this to be a different color, such as Neutral Tint. This gives a smooth transition of color with the strongest color at the tip of the brush. If you feel your brush is too wet, lightly tap it horizontally on your paper towel.

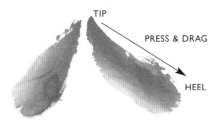

TIP

PRESS & DRAG

HEEL

Begin with the fall (dropping petals) facing you. Hold your brush at a 45-degree angle with the tip pointed away from you. Land the tip of the brush, press down on the mid-section, and drag the brush downward as shown. The strokes at the top will be somewhat shorter.

As your brush becomes drier, the process of pressing down will cause the tip to split. When you drag this split tip downward, you will create a wonderful effect. Use as many strokes as needed to create the shape. If you work rapidly, you may be able to do all of the strokes with one loading of the brush. If it is not possible, make sure that the bottom petals are consistent in tone with the preceding petals.

Note: Do not bring the tip of the brush to the outer edge of the petal, rather leave the tip halfway up the stroke and let the mid-section and heel of the brush complete the stroke. The tip of your brush stays facing the center of the flower.

Using the tip of your Best Detail brush and creamy Yellow, place dots and dashes as shown to indicate the Beard. Follow this with either your Happy Dot or Best Detail brush with Neutral Tint for the detailing. Use just the very tip of a dry brush. Let the brush tip dance along the edge of the petal. Vary the look of your strokes, and the amount of pressure exerted on the tip. Add various dots and veining for further enhancement. This centered line work is done with vertical brush movements. Make sure your petals are slightly damp when you do this.

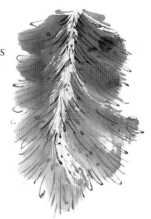

MID-SECTION TIP

The two other falls are seen in profile. For these, point your brush tip toward the center of the flower, then press down on the mid-section, and release. Start in the center and move in a more downward manner. Place each successive stroke a little lower on the paper as indicated. I recommend using a smaller brush, such as the Big Idea brush, and keep the moisture dry to medium. If you use your Large Orchid Bamboo brush, use only one-fourth of the brush. The detailing is the same as for the first fall.

If you prefer, show the underside instead. It is painted in the same manner with the tip of the brush pointed away from you. Insert the brush into the petal spaces, and then drag it down; reinsert and repeat.

START

TIP

STANDARDS

FLATTENED TIP

In the example, the standards are paler, so the Iris is bitone. Just add water to your reservoir to make it paler. Using your largest hard brush, land the tip at the top of the petal, then press down and drag the brush tip to meet the other petals. If your brush splits, all the better. Vary the height and width of your strokes; they may overlap slightly. Use all of the moisture as the stroke is completed to create a rough aspect that fades away. There are five strokes in this example. The loose detailing is also done in a light tone. Complete your Iris with a few dark accents placed in the center with strong Neutral Tint.

The Buds

The Iris buds protrude from many places along the stalk and they have an almost awkward aspect. Indicate the bud and calyx in a very rough and random manner. Add veining and outlining to complete these areas as needed.

BRUSH:
Large Orchid Bamboo

MOISTURE:
Dry

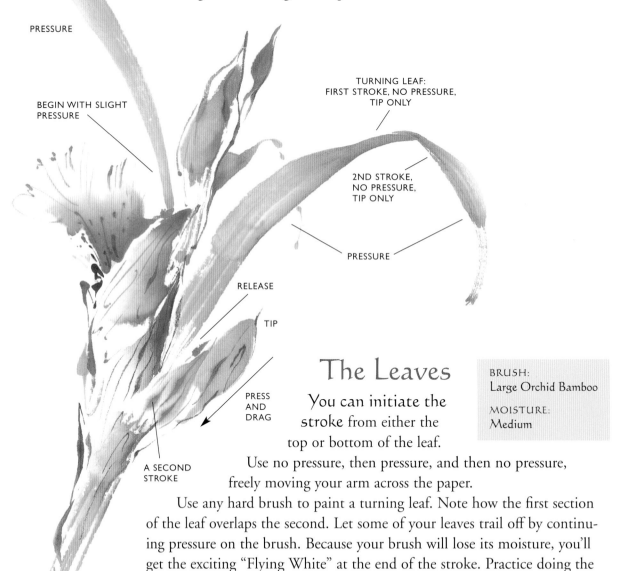

NO PRESSURE
TO RELEASE

PRESSURE

BEGIN WITH SLIGHT
PRESSURE

TURNING LEAF:
FIRST STROKE, NO PRESSURE,
TIP ONLY

2ND STROKE,
NO PRESSURE,
TIP ONLY

PRESSURE

RELEASE

TIP

PRESS
AND
DRAG

A SECOND
STROKE

The Leaves

BRUSH:
Large Orchid Bamboo

MOISTURE:
Medium

You can initiate the stroke from either the top or bottom of the leaf. Use no pressure, then pressure, and then no pressure, freely moving your arm across the paper.

Use any hard brush to paint a turning leaf. Note how the first section of the leaf overlaps the second. Let some of your leaves trail off by continuing pressure on the brush. Because your brush will lose its moisture, you'll get the exciting "Flying White" at the end of the stroke. Practice doing the leaves both from the end of the leaf to the base and from the base outward. For a larger leaf, place two strokes side by side.

The Bearded Iris has numerous buds
and flowers on each stem.
Additional petals appearing on your
Iris will indicate this effulgence.

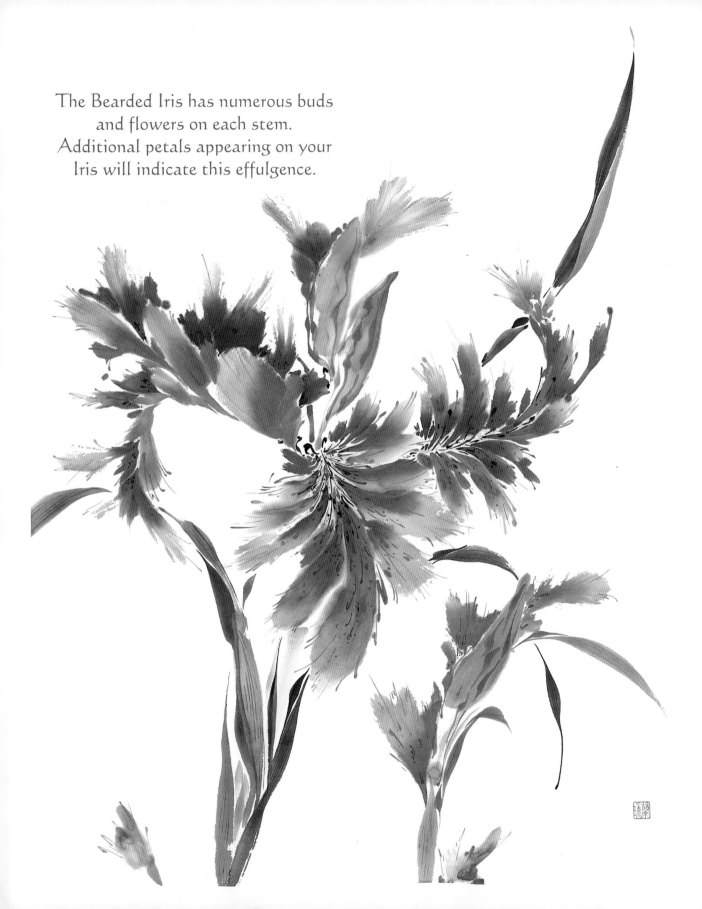

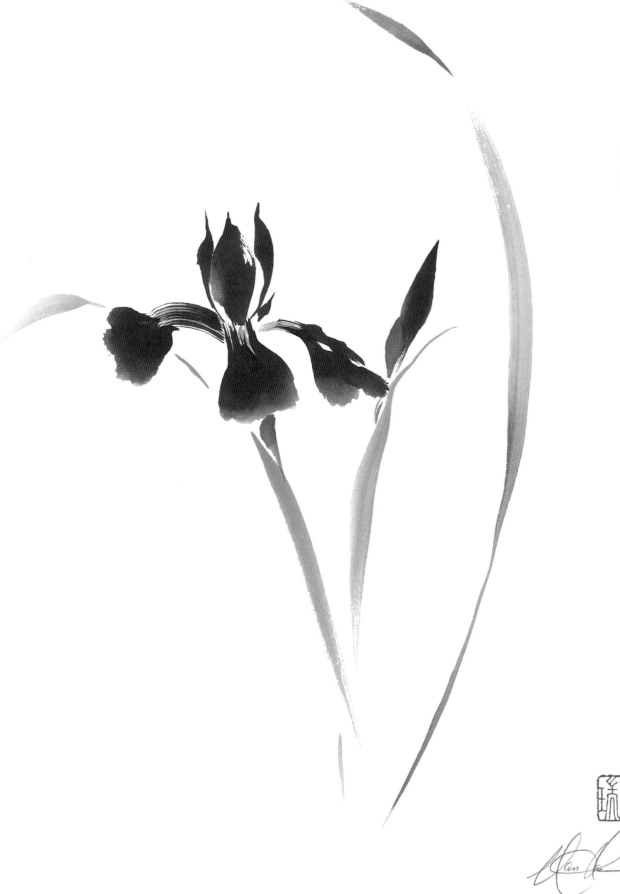

Japanese Iris
Minimalist Treasure

Everyone loves painting the Japanese Iris—it's what brush painting is all about! The simple purity of this flower speaks volumes and reveals why "less is more." Paint this gem with an economy of brushstrokes, working with unparalleled spontaneity and freshness.

While there are many different varieties of Japanese Iris, what you really want to convey is the basic nature of the flower. The flower can be up to eight inches across, while the plant can be up to four feet tall. The three falls tend to be very broad, while the three standards are plain and short. There are three more inner standards which are smaller still and do not need to be indicated.

The petal colors are White, Lavender, Pink, Rose, and, my favorite, Purple. Load your brush with strong color. As you mix in the color, bend the brush half way and work the color all the way into the top portion of the brush. To reserve space for the light Green that sprays out from the center, flatten and split the tip of your brush so that it leaves white paper showing as you create the stroke.

BRUSH:
Large Orchid Bamboo

MOISTURE:
Medium

COLOR:
Senneliers Blue Violet

Start with the center petal. Drag the split tip, then press down on the heel of your brush and push the heel slightly to the outside of the petal. Repeat this stroke to widen the petal, this time pushing out on the opposite side of the petal. For the two side petals, spread the tip in the same manner but not as much and press down on the heel as before. The upper portions of the flower are simply no pressure, press, and release. Vary your strokes and work rapidly to obtain a dancing quality. Fill the center areas that were left open with a Yellow Green.

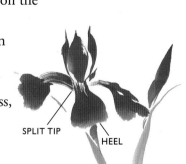

SPLIT TIP

HEEL

The leaves are thin and blade-like. I recommend that you only indicate one to three leaves at the most. Use you Large Orchid Bamboo brush and just let it sail up the paper. Voila! Paint the bud with a simple no pressure, pressure, and release stroke. Overlap the sheath and stem and you've got it.

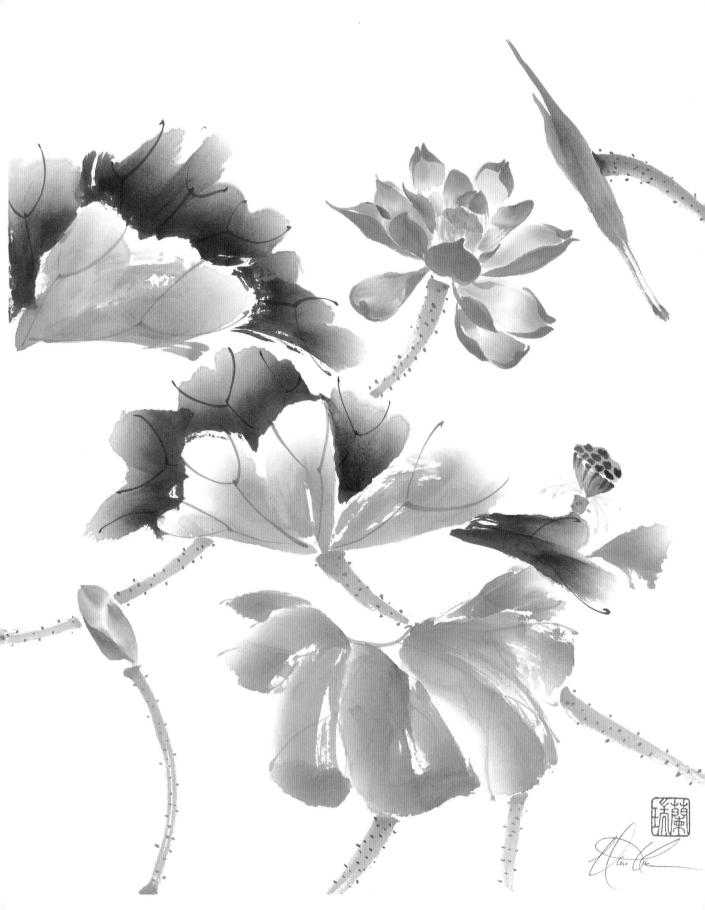

Lotus

Emblem of Purity and Truth

The Lotus is a multi-faceted blossom, with varying numbers of petals (twelve on average) and a charming array of colors. To achieve the most effective composition, I recommend that you begin by painting the dramatic leaves, as they occupy a large area of the paper. Lotus leaves are extravagantly large and umbrella-like in shape. They are sometimes more than three feet in diameter and seem to shield the blossoms that rise above them from the muddy waters. The rough aspect of the leaves serves as a wonderful contrast to the flowers.

Place the leaves, then move on to the flowers. Remember, the more abandon you paint with the better. This is definitely a subject where the maximum of meaning can be achieved with the minimum of means.

The Leaves

The leaves have a centrally-placed stem and veins radiating from a depressed center. The edges of the leaves sinuate in waves and may even curl backwards. When painting more than one leaf, be sure to vary the size, shape, and color tone.

Each brush, whether Large Soft, Mountain Horse, Large Orchid Bamboo, or Tiger 1 and Tiger 2, has its advantages. The Large Soft brush holds the most moisture, which is important to execute this wet stroke, but control is difficult. The Mountain Horse gives the most texture. The Tiger 1 and Tiger 2 brushes are the same as the Large Orchid Bamboo brush, only deliver a much larger stroke. These three brushes will give you a stroke with a smoother aspect. Whichever brush you choose, stay with it; do not switch mid-leaf.

To paint the essence of any flower you must first understand the plant. Notice how the flowers and leaves are facing in different directions, with some being partially hidden by others. Every portion of the plant must be rendered in its own full character.

BRUSH:
Your choice (the largest brush is suggested)

MOISTURE:
Very wet

COLOR:
Select one of the reservoirs listed on page 70.

When making your reservoir of color, mix enough color with water to paint at least an entire leaf. You do not want to have to mix a color at mid-leaf. Select one of these reservoirs of color:

1. A reservoir of Phthalo Green or Hookers Green with Lamp Black or Ink plus water. I recommend using more Black than Green, as the Green is very potent. For darker areas, touch the tip to Ink.
2. A reservoir of Blue-Green color. Use Yellow plus enough Indigo to turn the color more Blue then Yellow. For darker areas, touch the tip to Indigo or Neutral Tint.
3. A reservoir of Ink only. Work from reservoirs of Ink just as you would color. Dilute the Ink with water to create lighter and darker shades. Black is a color in Chinese brush painting and expresses the Lotus very elegantly.

Note: The underside of the leaf is lighter. If you are using a Yellow-Green color, add more water and Yellow, plus a touch of Vermilion worked into the tip.

HEEL TIP HEEL

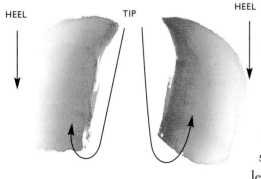

Touch one-third of your brush into the reservoir and remove the excess on your dish. Water-only at the top of the brush creates a lovely gradation of tone. The leaf is formed with a series of wipe strokes (see page 27) with a fully loaded brush. To form this stroke, which is fuller at its end, hold the brush parallel to the paper. Twist or push the heel of the brush around, letting the brush tip follow the heel as you drag the brush downward. Remember to keep the brush flat on the paper; you're using the side of the brush for the entire stroke. Flick the brush tip back into the stroke before lifting off the paper. Practice doing this wipe stroke in both directions.

STROKES

To paint the side strokes, lessen the amount of moisture in the brush and use only one-third of the brush length. Re-load your brush as needed for each stroke. The aspect of the Lotus leaf is very rugged. Remember to use "Flying White" (letting the brush skip along to reveal some paper) and have some portions painted with a dry brush.

The upper portion of the leaf is painted by leaving the tip at the center of the leaf (darkest area) and pressing down on the heel of the brush. To make this stroke wider, drag the heel to one side, leaving the tip in place.

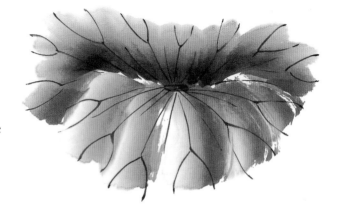

Use your Big Idea or Large Orchid Bamboo brush to paint folded leaves. The leaf is formed by two side-by-side strokes, one shorter than the other. Use no pressure, then press down at mid-point in the stroke, and then gradually release the pressure. These strokes look best when done in a rapid manner with the tip pointed away from you and at a 45-degree angle.

BRUSH:
Large Orchid Bamboo or
Big Idea for a smaller
flower

MOISTURE:
Dry to Medium

COLORS:
Various (see below)

The Flower

Visualize the Lotus flower carefully before you begin. Let your vision take shape and flow freely from your own personal impression of the flower. Let it flow from your heart, mind, and hand through your brush and onto the paper. Your painting will reflect your joy in this exciting and dynamic subject.

Lotus blossoms come in a charming array of colors. Choose from:

1. Pure White. To indicate a White flower on White paper, paint the petals in an outline manner.

2. Creamy White with a touch of pale Yellow; deeper Yellow for the accent.

3. White with Rose at the tip only.

4. Pale Pink with Deep Rose at the tip only.

5. Shades of Pink: Make a reservoir of thin White. Load your brush first with this White and then touch the tip to Permanent Magenta and work it into the brush one-third to one-half way. Make the accent color the same way, but add more Permanent Magenta to make a deeper tone. This accent color is used for the back side of the petals.

6. Pink with a purplish hue.

7. Deep Rose.

8. Ink only. A very dramatic Lotus painting can be done using Ink only.

Note: The interior petals of the Lotus are paler.

First, develop the basic "U" or cup shape. This consists of three petals and will determine the direction (general perspective) that your flower is taking. Many times the first petal is seen foreshortened. To do this, place the tip of your brush on the paper and press the midsection of the brush to the left and right to form the shape shown.

The two side petals have less interior showing and are painted in a stronger tone. They are painted with a Big Idea brush in a continuous curve that is largest in the mid-section. Hold the brush at a 45-degree angle. Using the tip of your brush, start the stroke with no pressure, press down to widen the stroke, then gradually release the pressure as you reach the center of the flower. Exert pressure only on the side of the brush where you wish to indicate more width. You may find it easier to paint all of the back sides of the petals before starting the lighter interiors.

To maintain the harmony of the remaining petals, visualize a hexagon balanced to the left and right of the axis of the flower. Remember that the petals overlap, so each petal must be shown behind the preceding petal. The sequence in which you paint each petal is crucial to the perspective. The petals in the back are facing you. Their full shape will be showing with perhaps some indication of the back side either on the sides or at the tip.

Some petals gracefully turn up or down at their tip to reveal the brilliant color of the other side. This may be expressed in two ways. First, press down on the tip of the brush and immediately release the pressure outward in a continuous curve. Repeat in the opposite direction.

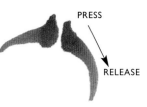

The second way is to start with no pressure, swing the tip of the brush toward the inside of the petal, and slowly swing back to complete the stroke. Use a dry Best Detail brush held vertically and do these strokes deliberately and slowly for maximum control.

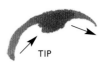

Finally, paint two petals tending downward to reveal the vital inner aspect. You may lightly fill in the inner petal areas or you may choose to leave them blank—you decide!

Use a very dry Detail brush to paint petals in the outline manner. Use pale Ink, Neutral Tint, Terre Verte, or any Pink/Rose color.

The Buds

BRUSH:
Big Idea

MOISTURE:
Dry

COLOR:
A deeper tone than the
inside of your petals

First paint the calyx, which is done in one,
two, or three strokes. Use a very pale Green with
just a touch of your flower color worked into the
tip of your Big Idea brush. Remove the excess
moisture on your paper towel. Hold your brush
at a slight angle with the handle pointed toward
you. Place the tip on the paper, exert pressure, and
then release the pressure.

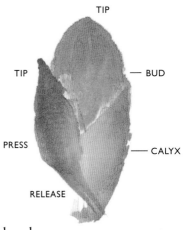

TIP

TIP —— BUD

PRESS —— CALYX

RELEASE

Now use your Big Idea brush to paint the bud. Hold the brush
parallel to the paper. Place the tip of the brush about an inch above the
calyx and press down. Repeat this stroke if necessary.

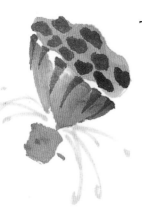

The seed pod contains some twenty edible, oval seeds.
The seeds protrude slightly from the flat top of the cupule.
When surrounded with petals, the seed pod is a strong
light Yellow Green and is covered with Yellow stamen.
You do not need to indicate the seed pod in each flower.
After the petals have shed, the seed pod remains, drying
and finally turning Brown. Pods add an element of drama
to your Lotus painting.

Using only the tip of your Best Detail or Happy Dot brush
held vertically, indicate the stamen with strong Yellow. You may
add White to your Yellow for a more opaque stamen. (Omit the
stamen to indicate a mature flower.) Start each stamen at the
base and then exert a slight amount of pressure at the end of the
stroke to form a slight bulb or rounded shape. Remember to vary
the lengths for added interest.

The Stalk

The Lotus stalks function similarly to the framework of a house. Keep the stalks strong as you descend from the flowers and leaves. Make a thumbnail impression on the paper first to indicate where the stalks will be placed. Start with the first part of a bone stroke (see page 28) to establish the width; slightly release the pressure on the brush tip as you descend.

The pressure determines the width of the stroke. Along the stalks are numerous hairs that are indicated as dots in a darker tone than the stalk. Before the stalk dries, use your Best Detail brush to paint the dots.

BRUSH:
Big Idea or Large Orchid
Bamboo

MOISTURE:
Medium to Dry

COLOR:
In keeping with your leaves

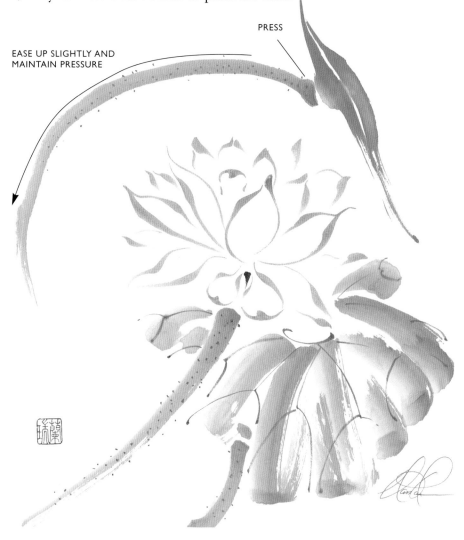

PRESS

EASE UP SLIGHTLY AND
MAINTAIN PRESSURE

Shadow Backgrounds

To take this wonderful subject even further, add a mysterious and exciting background. To do this, make sure that your painting is completely dry and then turn it over. Using a large Wash (Hake) brush, wet the entire back of your painting. While the painting is still wet, make reservoirs of the original colors used in your painting, but with paler tones. When the paper is barely damp to the touch, start painting in a rapid manner, echoing elements from the front, such as leaves and stalks, and filling-in broad areas with color.

If the Lotus is painted in Ink only, completely wet the back of your painting and make a reservoir of medium tone Quinacridone Gold. Working from this reservoir, make large horizontal strokes that are even in tone and blend together. As you approach your flowers and buds, take a dry, smaller brush, such as the Big Idea or Large Orchid Bamboo, and carefully fill in the surrounding area, staying at least one-quarter inch away from the flower edges to prevent bleeding. Mix Ink with Quinacridone Gold to paint accent shadows and marsh grasses.

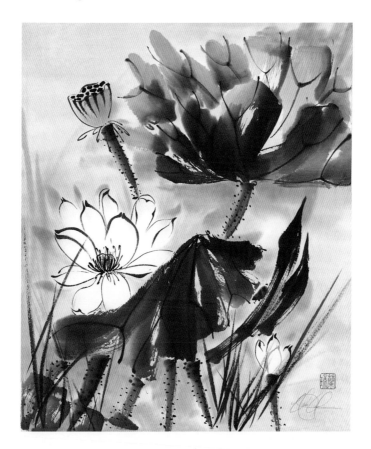

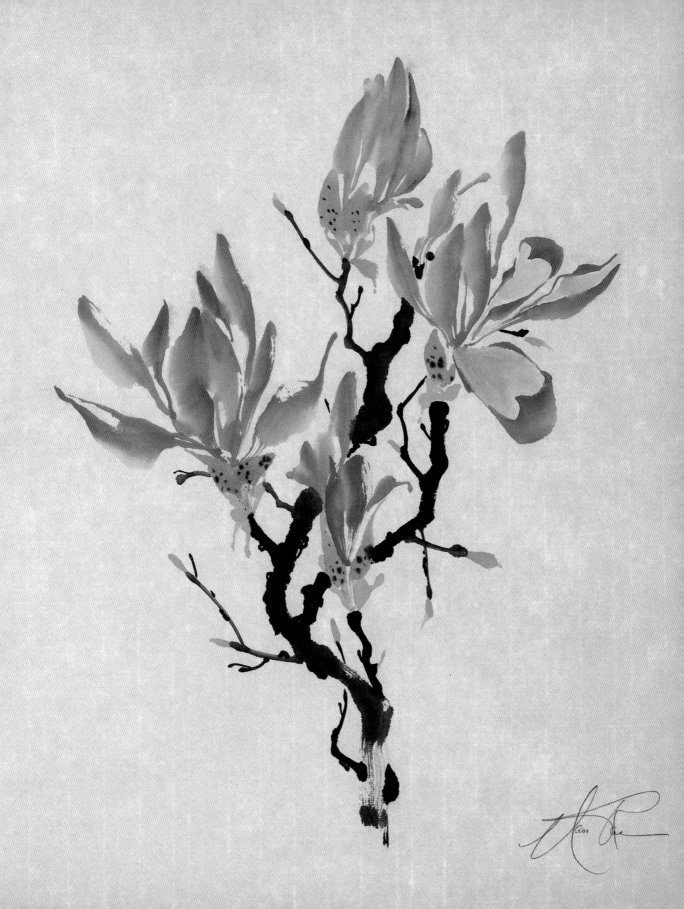

Chinese Magnolia
A Floral Ballet

One look at the impressive Chinese Magnolia is enough to perceive its tough but lady-like fiber. It's the strong fiber that trees are made of, and it gives this magnificent flower its enduring character and beauty. To paint and interpret this floral glory is a sublime experience, as the flower receives every grace and favor of nature. Approach the Magnolia with a loving hand and brush, and you will discover that it is supple and eager to reveal its character—a veritable floral ballet.

Plan your composition with thoughtfulness, but be prepared for unexpected happenings. Remember that less is almost always more, and invariably best. Be artistic yet sparse as you deploy your elements. A few well-placed flowers will have an effective impact, while too many will dissipate the energy and focus of your subject.

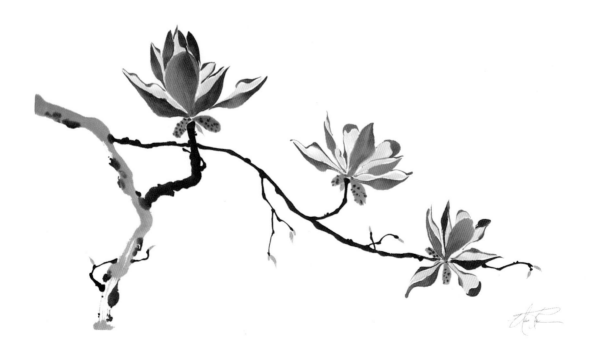

The Petals

Normally, you will observe nine to twelve Magnolia petals at three levels. The petals overlap or alternate; the outer three petals are shorter and more pointed, and the side petals show less of their interiors. The inner layer of petals is spoon- or cup-shaped. While the construction of the Magnolia is similar to the Lotus, we paint it in a much looser manner.

BRUSH:
Large Orchid Bamboo

MOISTURE:
Medium

COLOR:
Alizarin Crimson plus a slight amount of Indigo

The Petal Anterior is the outer aspect or back side of the petal, which is darker than the inside.

1. Dip one-quarter of the brush to a reservoir of White and remove the excess on your dish.

2. Touch the tip to Alizarin Crimson and work in one-third of the way.

3. Tip to Alizarin Crimson again, but leave the color at the tip. Do not work it in as much as you did the first time. Lightly tip to Indigo and work in.

4. Re-tip slightly to both Alizarin Crimson and Indigo.
 Your brush now has:
 Very pale White at the top or heel.
 Medium tone color in the mid-section.
 Strongest color at the tip.

BRUSH:
Large Orchid Bamboo

MOISTURE:
Medium

COLOR:
White and Pink

The Petal Interior is the inside of the petal, which is lighter in tone.

The base of the brush contains diluted White. Touch the tip slightly to Alizarin Crimson and work in until the tip color is Pink.

Before you begin to paint, determine whether you are indicating the front or the back of the petal, or a portion of both. I recommend painting all of the interior, pale portions first and then painting the darker accents.

To form a full petal, hold the brush at a slight angle to the table with the tip pointed away from you. Apply immediate pressure to the mid-section of the brush, drag the tip toward you, and lift. If you need to enlarge the petal, place another overlapping stroke alongside the first in the same manner.

An alternate method is to place the tip on the paper, then press down on the full length of the brush, and lift without dragging the tip.

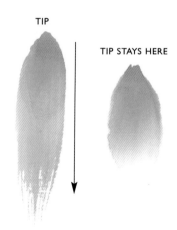

TIP

TIP STAYS HERE

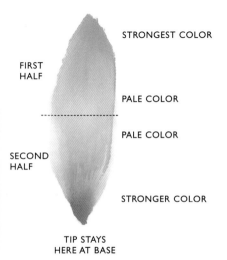

FIRST HALF

SECOND HALF

STRONGEST COLOR

PALE COLOR

PALE COLOR

STRONGER COLOR

TIP STAYS HERE AT BASE

For the interior of the petal nearest the center, touch the tip of the brush slightly to Yellow and then Vermilion. Reverse the position of the brush so that it points toward you. Keeping the tip of the brush at the base of the petal, press down on the heel and lift straight up. To enlarge the petal, add overlapping strokes.

As you add each successive petal, remember that it is most important that all of the petals either join or appear to be meeting at the center. Visualize!

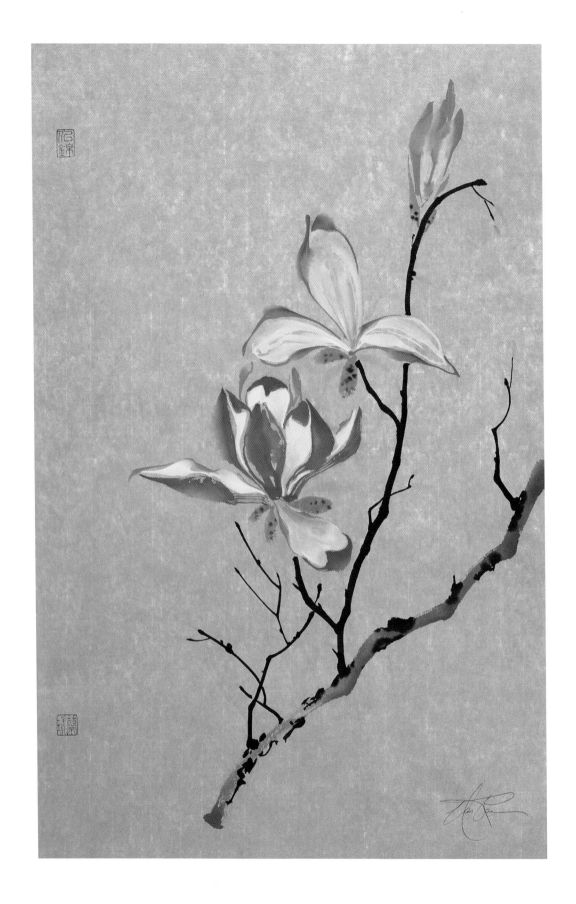

A petal gracefully turns up its tip to reveal the color of its underside. With your Best Detail or Big Idea brush, start with no pressure, then swing the brush tip toward the inside of the petal, and then slowly swing back to complete the stroke. Begin this stroke from either side of the petal. Another method is to press down on the tip of your brush and quickly release.

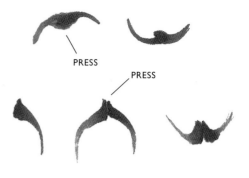

PRESS

PRESS

A petal that's seen from profile may be accomplished in one stroke. Starting with no pressure, apply pressure, and then release the pressure gradually to narrow the stroke. You should create a continuous curve that is largest in the mid-section.

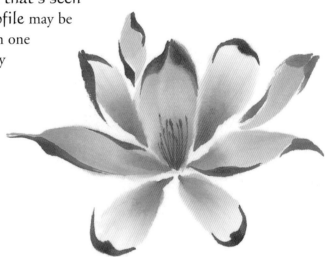

BRUSH:
Best Detail

MOISTURE:
Dry

COLOR:
Begins Rose (Alizarin Crimson plus Burnt Sienna) and turns Brown with age.

The Stamen

For a fully opened flower, you will want to indicate the stamen. Use a dry brush to paint the lines of the stamen in the flower center. A Yellow Green cone shape may also be indicated in the center of the stamen.

The Calyx

BRUSH:
Big Idea

MOISTURE:
Dry

COLOR:
Burnt Sienna mixed
with Ink and kept pale

The calyx is done in two strokes. Use a very pale Burnt Sienna with just a touch of Ink worked into the tip. Then, while the calyx is still damp, either line it or highlight it with a few dots of Ink. You may indicate the calyx husk under the full blossom if there is an appropriate opening.

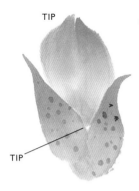

TIP

TIP

The bud may be accomplished in as many strokes indicating petals as you desire with a pale Purple on your brush. Place the tip of the brush above the calyx and land the heel halfway to the calyx. Then, with the brush pointing toward you, insert the tip into the calyx sections and press the heel back into the mid-section of the bud.

If desired, indicate very small, new leaves at the base of the flower and along some stems. Use your Best Detail brush and a light Green.

Branches and Twigs

BRUSH:
Mountain Horse or Big Idea

MOISTURE:
Dry

COLOR:
Burnt Sienna tipped to Ink
or Ink only

When painting Chinese Magnolia, we see clearly why stem work can be so important. The delicate, dancing flowers are supported by strong branches. If you have weak, uninteresting branches, the painting will be robbed of its vitality. To achieve a dramatic contrast, use only Ink to paint your branches. Use a very dry brush and "Flying White" to add even more excitement. The size of the brush you select and the amount of pressure exerted will establish the width of the stroke. As you descend, place more pressure to indicate joints, then ease up slightly and continue. Be sure the branch gets larger as it descends or connects to a larger branch (more pressure) and thinner as it reaches upward (less pressure). And don't forget to add moss dots.

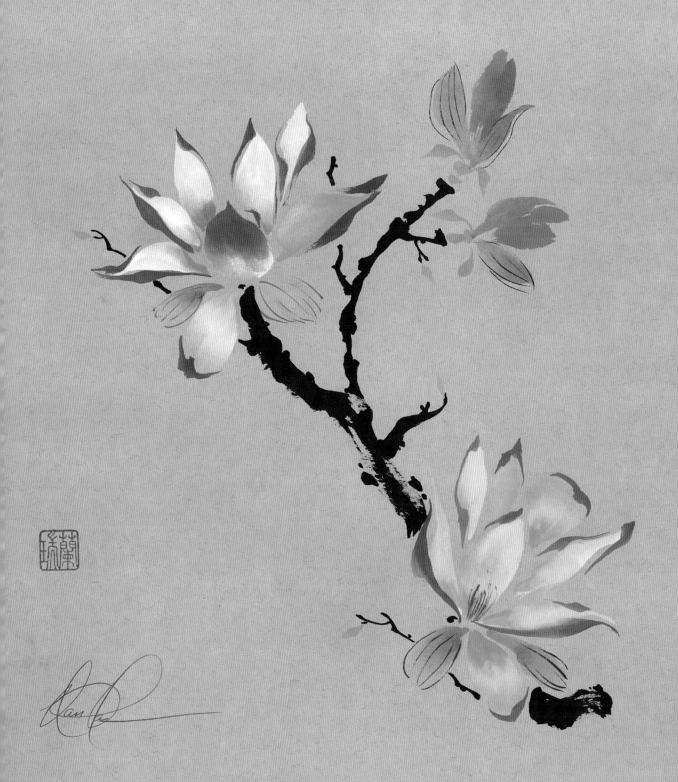

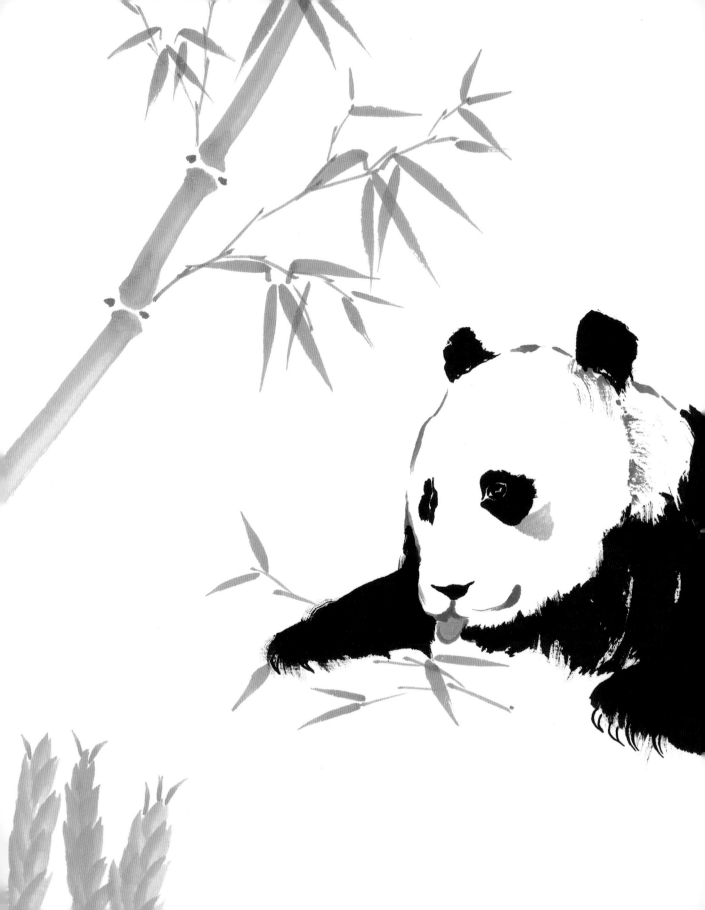

Part Three

Captivating Creatures

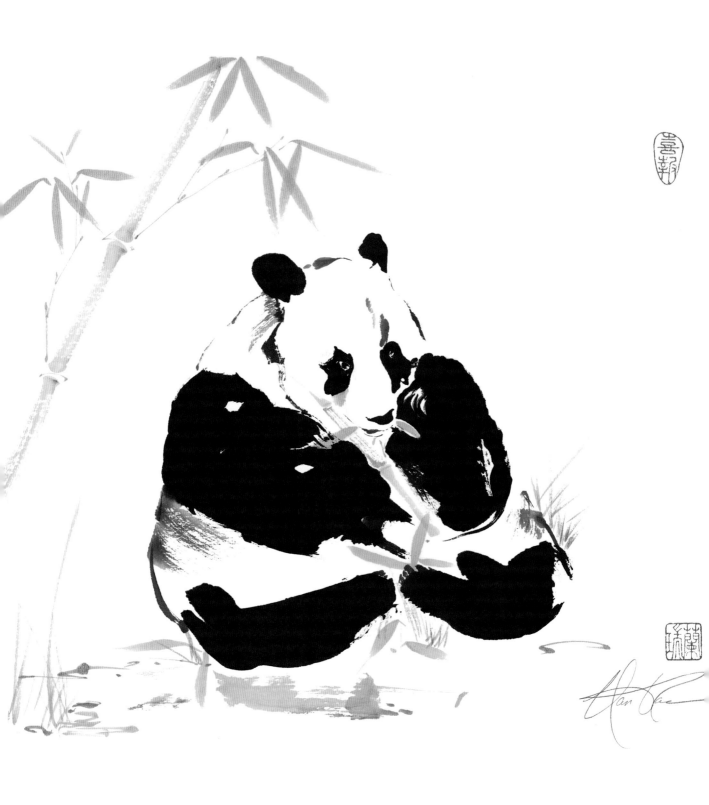

Giant Panda

Supreme Delight

The Giant Panda has the appearance of an oversized raccoon. In fact, scientists long debated on whether to classify it as a member of the bear or raccoon family, only recently deciding that it is a true bear. A quite large and lumbering creature, the Giant Panda eats primarily bamboo, which it chews on studiously and intently.

The Panda is a beguiling creature with black patches over its eyes, ears, and legs, and a black band across its shoulders. It is in a sense a fragile animal—physically big and powerful, yet not able to withstand or adapt to the encroachments of modern civilization. Though he may one day become extinct, the Panda will live forever as a symbol of nature's paradox—strong yet delicate, sturdy yet vulnerable, beautiful yet peculiar.

The risk in painting the Giant Panda is to project humanlike characteristics onto him. We must not do this, for the anthropomorphic approach rarely produces the desired result and, instead, gives us a cute or cartoon-like figure, not a grand philosophical idea. With at least one-third of the Giant Panda done in outline, we should resist the temptation to become illustrators. Instead,

The Giant Panda is perhaps at his finest when seen as a symbol, a vivid flower in black and white: the eye patches are two stamens, the nose is the calyx, the ears are lovely plum blossoms, the limbs are wide branches that bend at their joints. Without a poetic approach to the Panda, all you'll be painting are big raccoons.

paint the Panda as if a fleeting glimpse—he is at his best when seen as rare and elusive, a swift blur of black and white. The Giant Panda is a symbol of life in a changing world. Painting this delight in *Po Mo,* or throw-ink style, can say much about life while expressing our best and innermost self.

Painting the Panda

The eyes reflect the spirit of the animal. Use your Best Detail brush to paint the Giant Panda's almond-shaped eyes. Form the eyes by painting a coiled, comma-like stroke with the tip of your brush and Ink. Do not add water to your Ink. (Please refer to Moisture Control with Ink, page 33.) Outline the eyes with a thin line.

Paint the eye patches with a Big Idea brush, medium moisture, and undiluted Ink. Hold your brush at a 45-degree angle with the tip pointed toward you. Place the tip of the brush at the inner corner of the eye, press down slightly, and drag the brush across the top of the eye.

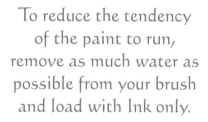

Reload your brush and repeat this stroke under the eye with the brush pointed away from you. Press down more on the mid-section of the brush to make a longer stroke. Extend the stroke outward, as shown, with the tip of your brush.

Additional strokes may be added as needed to fully circle the eye.

Form the nose with a flick of a stroke—no pressure, press, and release. Use just the tip of your Best Detail brush.

To reduce the tendency of the paint to run, remove as much water as possible from your brush and load with Ink only.

The Panda is very jowly with a pronounced snout. Indicate his round, full cheeks and narrow top of the head with a minimum of strokes in a very pale tone and a very dry brush. Vary the pressure on this line work.

BRUSH:
Big Idea

MOISTURE:
Medium

COLOR:
Undiluted Ink

The Ear

Place the ears somewhat close together and almost directly above the eyes. Exert pressure on your Big Idea brush and wipe sideways. The tip is pointed toward you and dragged along the top of the head. The mid-section of the brush forms the upper portion of the ear.

When painting the limbs, always remember to indicate the bend in the joints. Limbs are painted with a minimum of strokes using a Basic or Large Soft brush loaded with undiluted Ink. Holding the brush at an angle, press and swing the brush around. End the stroke by applying full pressure on the heel. Flick the tip into the limb area to terminate. (Refer to the section Bone Work on page 28.) Try to have the tip split as you release the stroke to indicate fur.

If you would like to paint the Panda in a more realistic manner, begin by making a very pale outline or sketch of the Panda, then fill in all of the necessary areas. Initially, try tracing the Panda to become familiar with the shape and the strokes.

Use a few pale strokes of varying pressure to indicate the white body. Paint with just the tip of your Best Detail brush, making sure the brush is very dry. Note that there are five large claws (nails) on each pad that may or may not be indicated. You might also want to indicate his fur by using a very dry brush and forcing the hairs to split. You may also indicate his Pink tongue and White whiskers.

As with flowers, the Panda must be studied and understood in order to be painted in a free and joyful manner. Collect photographs of Pandas and then capture the various poses using a minimum of strokes.

Bamboo

The Panda's food of choice is Bamboo, and his native habitat are the Bamboo forests of Central China, so a few branches are in order.

BRUSH:
Small Soft

MOISTURE:
Dry to Medium

COLOR:
A reservoir of Ink or any shade of Green. Note: I prefer using a Yellow Green mixed with a slight amount of Ink or Quinacridone Gold.

The Culm

A Soft brush works best when painting the culm, as it holds more moisture and the hairs yield easily. For a large culm, use a large Soft brush and only dip the sides of the brush into your color or Ink reservoir. This will give you a gradation of tone.

Flatten the hairs of your brush and then gently dip into your color. Follow that by lightly tapping the flattened hairs on your paper towel to remove the excess moisture.

1. Start off at the top of your paper. Holding the brush with the tip pointed toward the top of the paper, press down and maintain the pressure as you travel one-third of the way down the page.

2. At that point make a movement, in place, going slightly to the left and to the right with the tip of the brush. Re-center and flick the brush back upward to release. This is a modified bone stroke used to form the joint area (see page 28).

3. Drop down about one-eighth inch and make the same side to side movement. Release the pressure slightly and continue downward ending with the joint, repeating step 2. Repeat these steps for each Bamboo segment.

4. Finally, place a dot on either side of the joint areas to indicate the fragrant spots, which are the points on the branches where the leaves grow (please refer to the images on pages 93 and 94).

The Stems

The stems begin at the top portion of the joint. Hold the brush at a 45-degree angle and paint with just the tip of your brush. Exert a slight amount of pressure at the beginning and end of each stroke to create a slight bulb. Note that the stems are deliberate strokes done slowly and with a very dry brush.

BRUSH:
Best Detail

MOISTURE:
Dry

COLOR:
In harmony with your culm

It is an important detail to remember that the stems form a narrow angle as they join one another.

NARROW ANGLE

To paint new shoots, just think of asparagus and you've got it! Use just the tip of your Best Detail brush (dry) and overlap the strokes as illustrated.

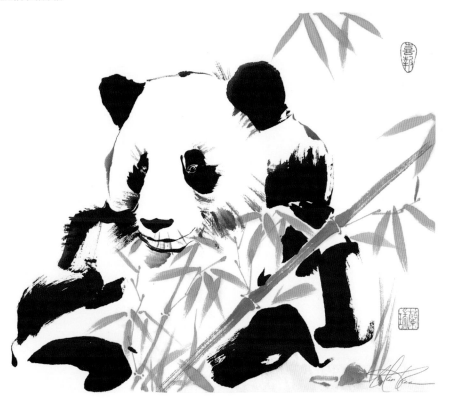

The Leaves

The leaves are the most important part of the Bamboo, and the Bamboo leaf stroke is one of the most pleasing to execute. The leaves are done very freely with a very wet brush; however, the brush is never fully wet, and you must always control the moisture. Each cluster of leaves has the same Ink or color tone. Do your dark strokes first to achieve a gradual progression of tones moving from dark to light.

Use your Big Idea or Large Orchid Bamboo brush to scoop up enough Ink or color to cover one-third of your brush. Shape the tip and make sure the longest hair is straight. Hold your hand further back on the brush at about the mid-point.

The tip of the Bamboo leaf is made by the movement of your arm instead of the movement of your fingers on the brush. Your arm remains parallel to the paper as you pull your elbow back. This stroke is done rapidly, especially when crossing over other leaves. Apply pressure on the brush when you initiate the stroke.

This will form the blunt head of the leaf. Pull the brush straight across the paper, then three-quarters of the way down the stroke, gradually release the pressure. Do this by pulling your arm back, raising it slightly, until only the brush tip is touching the paper.

Remember that the tip of the brush is always in the center of the stroke. This is a single, smooth motion done from the shoulder with the leaf straight, not curved.

Bend the brush with less pressure to make a thinner leaf; apply more pressure to make a thicker leaf. Paint leaves seen from the side as shorter and slimmer.

On a windy day, you may see part of the Bamboo stem. To create this aspect, at the end of your stroke work the brush tip slightly upward, applying no pressure, and then immediately bend the brush down. This movement requires more control—persevere, but take your time and maintain your own pace.

Group two, three, or five leaves together to form a cluster. Do not combine very large leaves and very small ones in the same cluster. Note the pattern shown in the painting examples. Try to achieve as much variation as possible. Have leaves touching and crossing each other, while other leaves are shown separately.

The faster you do your leaf stroke, the sooner you can cross over or paint over damp leaves. If the stroke is done too slowly, the leaves will expand at the point where they cross due to the excess moisture. When in doubt, wait a moment before painting cross-over leaves.

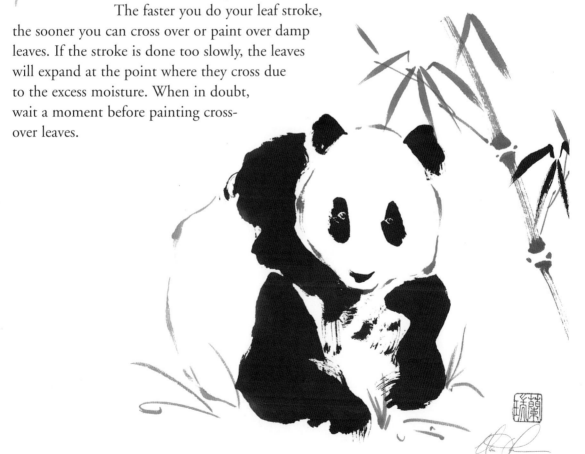

Giant Panda

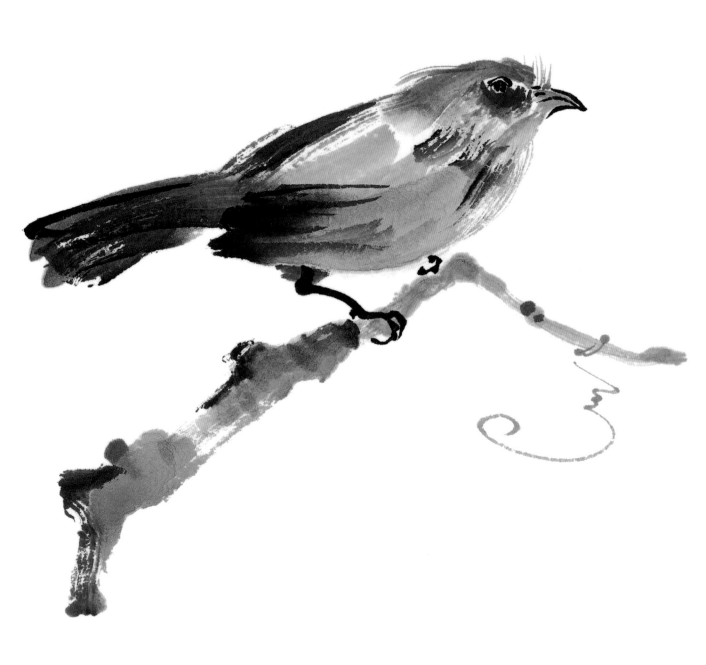

Little Birds

Friends of a Feather

A little bird is a charming addition to a flower painting, perhaps perched on a Wisteria branch. As a stand-alone subject, a bird can be delightful seen gazing at berries or just enjoying the day. As with all Chinese brush paintings, less is definitely more than enough; apply an economy of strokes, leaving at least one-third, if not more, of your paper blank.

The Eyes and Beak

BRUSH:
Best Detail

MOISTURE:
Very dry

COLOR:
Ink

We begin always with the eye, defining the spirit of our little friend. Use just the tip of your brush to paint a semi-circle with a small arching line added above that.

Next paint the beak. Again, without reloading, use just the very tip of your brush to execute the three strokes. Work at getting a slight arch in the lines and just a little hesitation at the corner of the mouth. Add a little line to indicate the nostril.

The Crown, Back, and Chest

BRUSH:
Small Soft or Big Idea

MOISTURE:
Dry to medium

COLOR:
Your choice

When painting the crown you want to avoid the eye area. Place the tip of your brush near the beak, press down, and lift. For the back, flatten and separate the hairs of your brush to make feather-like strokes. (Please refer to the section on wipe strokes on page 27.)

The chest is done in the same manner as the back. One or two strokes will indicate the chest area. Fill in areas as needed with delicate, feather-like strokes. Keep in mind the egg shape of the bird when painting the back and chest.

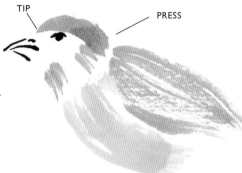

97

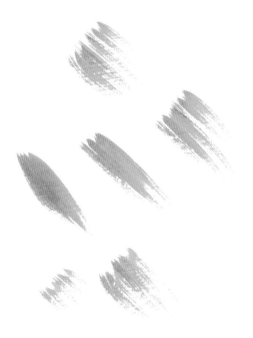

When painting the feathers on the back and crown, try flattening and spreading the hairs of your brush to create interesting effects. Do several of these to see the various looks you can get. Remember to work with a dry brush.

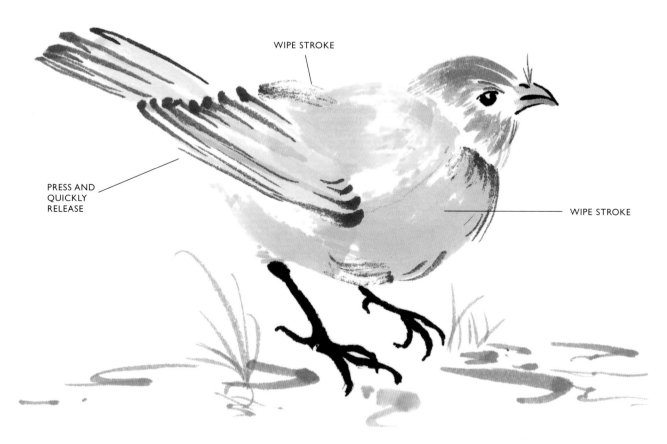

WIPE STROKE

PRESS AND
QUICKLY
RELEASE

WIPE STROKE

Let the bird dry until
barely damp. For the tail
feathers and wings, apply
a combination of short and
long press and release strokes in
Ink (or any color of choice) with
your Best Detail or Big Idea brush.
Use as few strokes as possible. Tail feathers
can be accomplished in just two strokes.

Fill in the beak with pale Vermilion
using the tip of a very dry Best Detail brush.
Add any feather highlights, including light feather-
ing where the beak meets the crown.

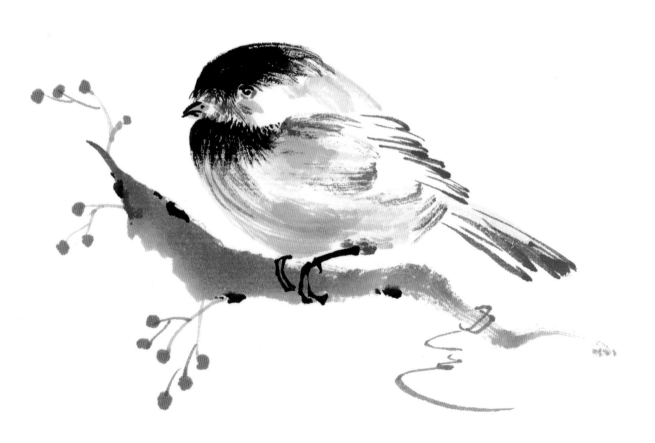

Little Birds

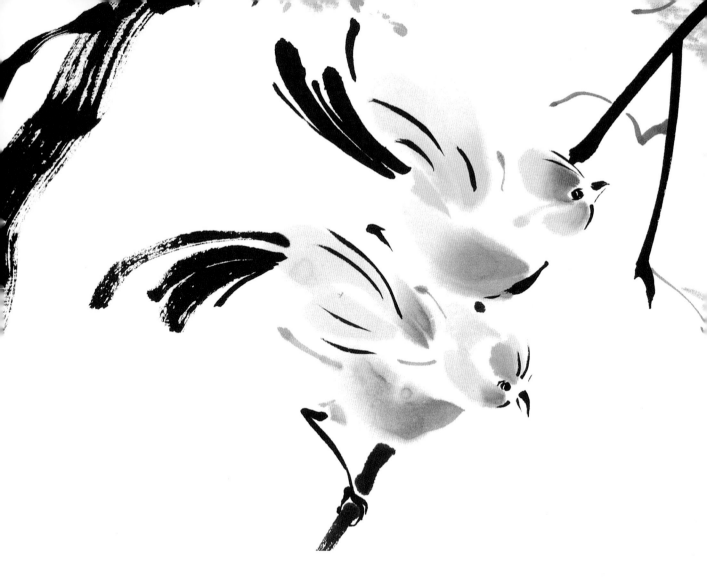

BRUSH:
Best Detail

MOISTURE:
Dry

COLOR:
Ink

The Feet

The feet have a claw-like aspect. Just a little pressure on the tip of your brush will form the joint areas of the feet. The bird may be cute, but the feet are definitely serious. Use just the tip of your brush; if it is dry enough, you will be able to paint slowly.

After the feet are dry, paint in a rugged branch and a few leaves or berries. Now all that's needed is the song!

This handsome fellow is certainly in charge. He will look most splendid if you do a few layers of various color tones as shown. Be sure to keep your colors transparent and do not go overboard. The beak has a little Yellow mixed with Vermilion.

To create a rugged branch, use any brush held at an angle and apply no more than one-third of the hairs. Bend the bristles to accomplish this. If your brush is very dry you will create a rough aspect, with "Flying White" where the paint skips along, revealing some of the white paper. If desired, go back in and add some more dots for extra texture.

For the berries, merely use the very tip of your brush and make a circular movement in place. The brush should be dry and the color not too intense.

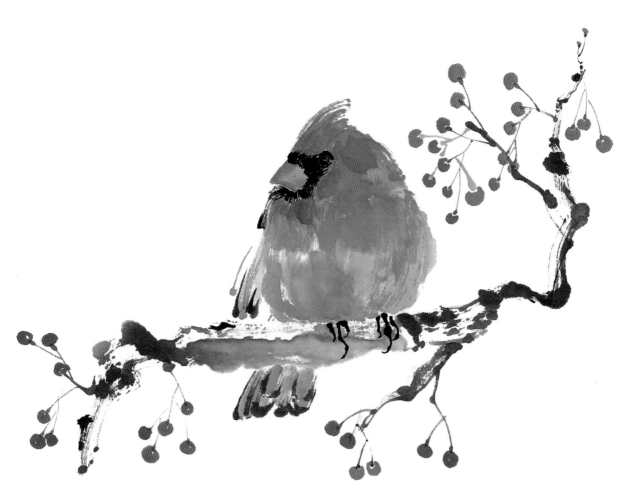

Little Birds

The Hummingbird

The hummingbird is a buoyant and colorful creature that, when painted with a free spirit and mind, will appear to lift right off your page. To give your Hummingbird a light, delicate aspect, keep all your colors pale. Remember everything is a flower, free and flowing in the breeze. Always paint your birds as if you are painting flowers in a lovely flight of feathered fantasy!

Paint the beak and eye with a Happy Dot brush, dry moisture, and Ink. The beak is done with simple line work, and the eye a basic dot stroke.

Paint the Hummingbird's crown and throat with your Best Detail brush, dry moisture, and your choice of colors (Viridian and Alizarin Crimson are shown here).

Use your Best Detail brush to paint shorter feathers; use a small Soft brush for longer feathers. Make a reservoir of pale color (a Yellow Green is used here). Saturate the brush, and then wipe it on a towel until almost dry. Fan out the hairs of the brush and drag one side only through a darker color (Viridian is used here). Push the brush hairs together slightly if they appear too fanned out. There will be enough on your brush to do all of the feathers.

Continue the second wing with the color remaining on your brush. Proceed with the tail feathers and, if necessary, reload your brush in the same manner as the last step. Feather in the back area with a small Soft brush, using a reservoir of color that is different than the wings.

Fill in the beak with pale
Vermilion mixed with Burnt
Sienna.

Make a reservoir of pale color for the
breast. Feather in the breast area using a Soft
brush and long sweeping strokes as shown.
Round the breast in a wide curve, meeting and
sometimes sweeping over the throat.

To finish, draw the feet below the breast
with a dry Happy Dot brush and Ink.

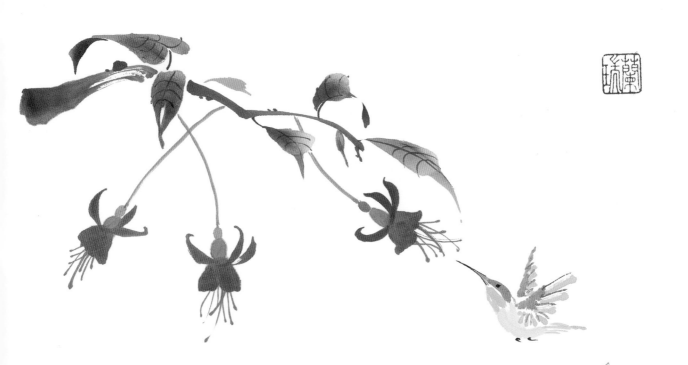

Little Birds 103

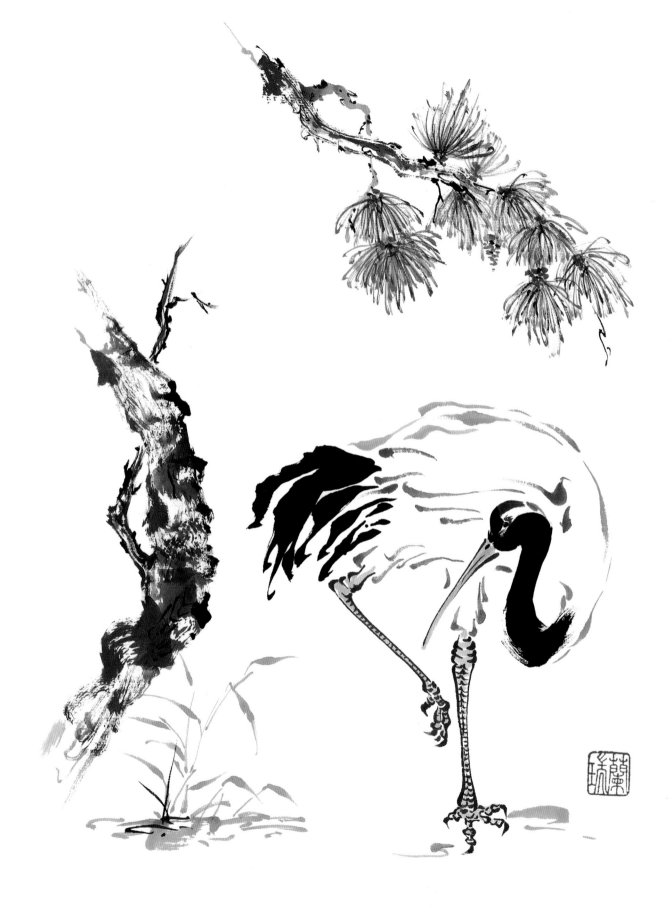

The Crane
Great Bird of Happiness

Of primary importance in painting any animal or bird is that you connect with your subject. Notice the particular stance or characteristics of your subject as well as its bearing.

Cranes are symbols of love, loyalty, and good fortune. They are regal and calm birds, and you want to convey those aspects in your painting. You may paint the Crane with either rough, expressive strokes or with smooth, elegant strokes.

As when painting any bird or animal, always start with the eye to capture the Ch'i of your subject.

The Eyes and Beak

Paint the eye with your Best Detail brush and undiluted Ink. Begin with a circle to form the pupil. Outline the circle with a thin, paler line. Using a pale tone and a dry brush, place a few feathered strokes around your outline as shown.

Paint the beak with a very dry Happy Dot brush. Work from a reservoir of pale tone Ink. The lines of the beak are thin with a slight curve; it will take a little practice to control the strokes. When the beak is completely dry, fill it in with a pale tone of Yellow with a scant amount of Vermilion and Ink added.

The Head

To paint the crown of the head, place the tip of your brush, press down, and pull the tip to the back of the crown as you release. Be careful to avoid the eye area.

To paint the neck, start by exerting pressure on your brush and travel downward as you turn. This may be done in two or three strokes. Release pressure on the brush to complete the dark area. If possible, let the hairs of your brush split as you lift off the paper to indicate feathers.

RELEASE

TIP

START

RELEASE

BRUSH: Best Detail

MOISTURE: Dry

COLOR: Red

BRUSH: Best Detail or Big Idea for a larger Crane

MOISTURE: Medium

COLOR: Undiluted Ink

The Body

Use a very dry Best Detail brush to paint the Crane body. Working from a reservoir of pale tone Ink, indicate the body with a series of light, graceful strokes. Vary the strokes in width to create a sense of depth and enliven the image. Remember that less is more.

BRUSH: Big Idea or Large Orchid Bamboo

MOISTURE: Medium

COLOR: Ink only

When forming the tail feathers, relax your manner and don't overdo it. This is your chance to express yourself and let the Crane preen. Use vertical strokes with your brush held at a slight angle. Vary the strokes for interest, making some longer and some wider. You may create one or two with your brush held at a 45-degree angle using at least one-quarter of the side of the brush. For added effect, finish with two or three dry strokes.

An interesting way to paint feathers on open wings is to load your brush with thick White, spread the hairs somewhat, and then load one side with a medium Gray. Press down slightly on the brush for the full length of the stroke. Paint the next feather in the same manner.

With Ink only in your brush, you can work in a slow, deliberate manner. Undiluted Ink has much less tendency to run.

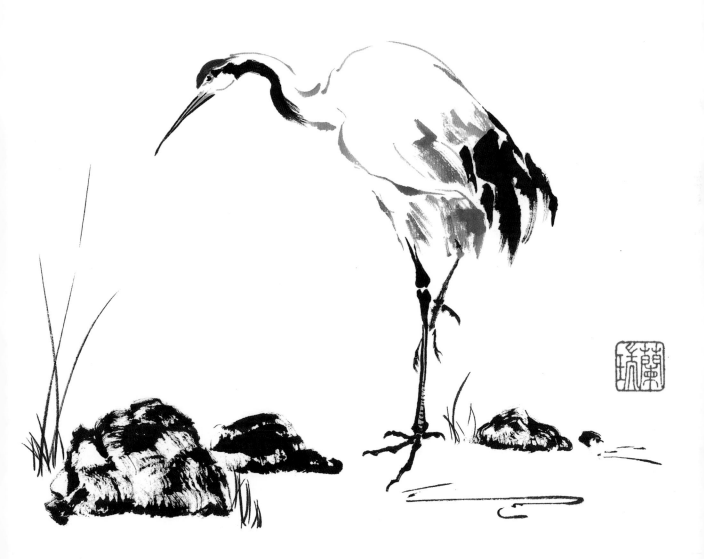

The Legs and Feet

There are two ways to depict the legs: either in the outline or the solid manner. Whichever you choose, keep in mind the sturdy nature of the legs and the claw aspect of the feet. These are not dainty!

The Outline Manner: Using only the tip of your Best Detail brush, outline the legs as shown. The brush should be dry and the tone pale. Note the pressure points where the lines thicken. Allow the Ink to dry, then fill in with a pale tone of Yellow plus Vermilion toned down with a scant amount of Ink.

The Solid Manner: Use only Ink and a dry brush held vertically to paint the legs in the solid manner. Use a bone stroke to indicate the joint areas (see page 28). Keep your brush dry!

Tea Washes

You will love using tea washes and you will find them a wonderful way to give your paintings, including floral paintings, a beautiful antique look.

Make a strong tea solution using about five tea bags per cup of water. Allow the tea to cool completely. When your painting is absolutely dry, turn it face down and wet the entire back with a Wash (Hake) brush. Allow the painting to dry until barely damp. If you wish to show a moon in your painting, take a glass the size you would like the moon to be and place it rim-down on the paper. Remember that we are still working from the back side with the Wash brush. Working from your tea reservoir, make smooth horizontal strokes across the paper, starting at the top of the painting. As you approach the moon, hold the glass firmly in place and paint to it, then lift the brush to the opposite side of the glass, and continue across the paper. When you reach the Crane, stop one-quarter inch away and restart one-quarter inch on the other side. Dip a small brush in the solution, remove the excess moisture, and paint the area around the Crane as needed.

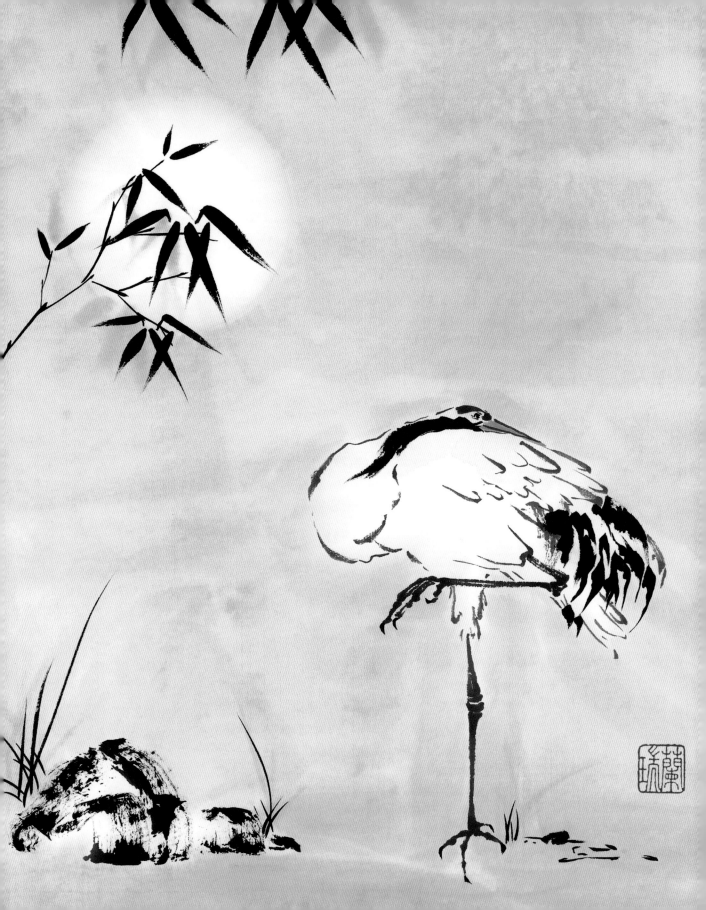

Working with Opaque White

When experienced viewers look at a Chinese brush painting, they want to be able to read the artist's brushstrokes. This quality is central to the art, where the spontaneity of the stroke and translucent quality of the pigment is admired, and it is another reason why you do not go over or correct any strokes. That said, there *are* instances where using opaque White works to great advantage. For example, when you paint a subject on colored paper or on paper where you will add background washes.

A Crane painting offers a good opportunity to experiment with opaque White. Use landscape paper because it resists tearing. Paint your Crane as before, making sure that all of the features are painted including the Black tail feathers. When outlining the bird, keep the tone as pale as possible, merely placing indications or guides to the White areas to come. You may wish to indicate some shadow areas in the Crane using a dry brush and a pale tone of Ink. Paint any background elements you wish to include and allow the painting to dry completely.

Next, turn your paper over and wet the back side completely with your Wash (Hake) brush. Allow it to dry until barely damp. Meanwhile, make reservoirs of the colors you wish to show in the background, being certain to mix enough to finish the entire painting. The color should be light to medium tone.

Dip your Wash brush into the reservoir and paint from side to side across the paper, starting at the top. If you wish to include a moon, now is the time to do it. Keep a Soft brush loaded with clear water handy to blend in areas that appear too hard. You want an even, soft effect, which is why you are painting on the back side.

As you approach the bird, stay at least a half-inch away and continue down the paper. Then, take a Soft brush, dip it in the same color reservoir, dry the excess on a paper towel, and paint around the Crane, staying at least one-eighth inch away to avoid color bleeding. Next, use tones deeper than the background wash to create interesting shadow effects.

After your painting has again dried to barely damp, carefully turn it over to begin working on the front with opaque White. Using feathery strokes, paint in the head, body, and all White areas of the Crane. If the paper absorbs the White, go over your strokes so it does not get lost.

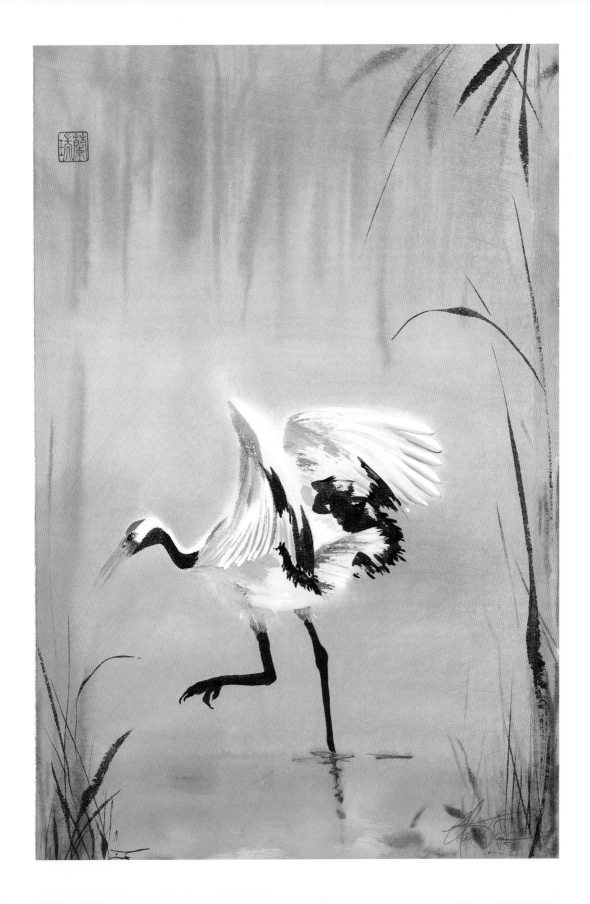

Background Enhancements

Create a happy environment for your Crane to flourish in. Suggest a ground with rocks and grasses, and add branches to balance and harmonize the setting.

Painting rocks will be quite easy for you. Simply use the full length of your brush and wipe around to form a rock. Keep the brush dry and add as many strokes as needed to complete the shape.

You may use any brush to paint rocks, but a Mountain Horse brush will give you the most texture.

For the base of the rock, land the full length of the brush flat on the paper and, after pressing down, lift up, dragging the hairs upward into the lower third of the rock.

Rocks are so rewarding because you can create a dynamic effect with just a minimum of effort. Practice dragging your brush around in arching strokes to form the shapes. Remember that your brush needs to be dry to create interesting rock textures.

A few blades of marsh grass will have the wonderful effect of placing the Crane in its element. Use the tip of your Best Detail brush and lightly paint in a few strokes. Have some strokes cross others.

Just a section of pine branch with a few needles will have a dramatic effect. Use the side of the tip of a dry brush to indicate a rugged branch. With the tip of your brush and a dark tone Ink, indicate a few more dots along the edge of the branch.

For the pine needles, use the tip of a dry Best Detail brush held vertically. Paint a series of lines as follows:

First, establish the basic shape with a pale tone.

Continue adding strokes, varying the lengths and having a slight pressure point at the end of each.

Reinforce the shape with more strokes in a deeper Blue/Gray tone.

Finally, still working with the Blue/Green tone, spread the hairs of your brush and stroke through the shape you've created until the needles have the desired fullness. For added interest, you may add dry, rough dots under the pine needle sections to indicate pinecones. To do this, use a Gray/Brown tone and the tip of your Best Detail brush held at an angle.

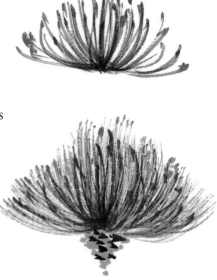

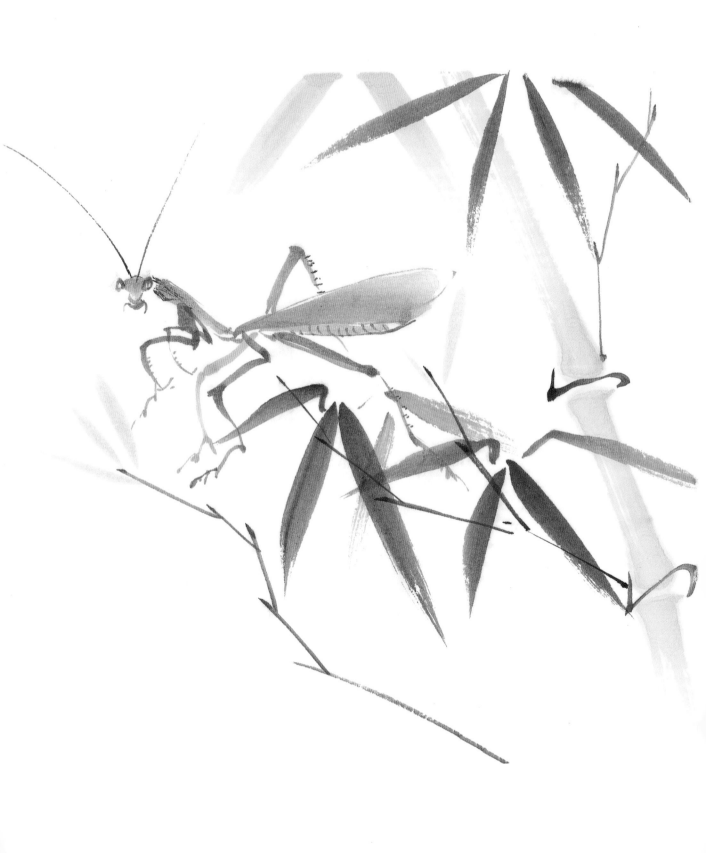

Insects

Small Wonders

Insects are arthropods, which are invertebrate animals that have jointed limbs, a segmented body, and an exoskeleton made of chitin. Other arthropods are arachnids, centipedes, and crustaceans. Insects have six legs and three main body parts, usually two pairs of wings, and two antennae. The three body sections are the head, thorax, and abdomen. The thorax is divided into three segments with a pair of jointed legs attached to each segment.

We'll be painting some of my favorite insects, starting with the Praying Mantis and followed by Dragonflies and Damselflies, Butterflies, Crickets, Grasshoppers, and finishing up with Ladybugs.

The Praying Mantis

How on earth did a bug that looks so strange get the name Praying Mantis? Well, while waiting for dinner to walk or crawl by, the Mantis folds its front legs as if praying. These two front legs are much longer and larger than the others.

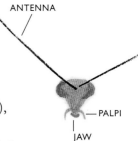

ANTENNA

PALPI

JAW

BRUSH:
Best Detail

MOISTURE:
Dry

COLOR:
Yellow Green such as Sap Green or a toned-down shade such as Senneliers Terre Verte

The head contains the brain, a pair of antennae (feelers), two compound eyes, and, of course, the powerful jaws! Next to the strong jaws, Mantises have tiny feelers called palpi, which are used to manipulate and taste food.

The main aspect of the head is its triangular shape. This is formed by a subtle manipulation of your brush tip, pressing down to form each side. If desired, add two side dots or semi circles to indicate the eyes and further emphasize the shape of the head.

Use just the very tip of your brush to paint the palpi. Indicate the jaw with a thin Vermilion line.

Paint the antennae with a medium to dark tone Ink and a dry Happy Dot brush. I like to add these last as a final dramatic flourish.

HEAD

THORAX

BONE
STROKE

ABDOMEN

BRUSH:
Best Detail

MOISTURE:
Dry

COLOR:
Same as head

The thorax has three segments; each segment has a pair of jointed legs. This is where the wings attach and the flight muscles are located.

Paint the thorax with a modified bone stroke (see page 28). You can indicate the three segments in one stroke.

TIP

WINGS

WIPE
DOWN

ABDOMEN

The wings should be done in a very pale tone and with a light and free manner. Merely wipe across the paper using the upper third of the brush. Let the paper show through (Flying White), and define the shape later with an exaggerated outline.

BRUSH:
Best Detail or Big Idea

MOISTURE:
Dry

COLOR:
Translucent Green to Brown tone

The abdomen encloses the heart and digestive system, as well as the reproductive organs. Paint the abdomen with a dry Detail brush and Vermilion touched with Burnt Sienna. Use a dry Happy Dot brush with Green mixed with Brown to do all of the detail work. Use the tip of the brush to outline the wings. If you go slightly outside the area of color, you will make the wings even more fragile looking. Line the veins on the wings and line the abdomen, as shown.

You will use the Best Detail or Big Idea brush to paint the wings for all of the insects.

BRUSH:
Best Detail or Happy Dot

MOISTURE:
Dry

COLOR:
Same as head

Use a bone stroke to paint the upper portion of the front legs (see page 28). Paint the mid-section of the leg in the same manner as a small vertical leaf stroke (see page 36). Don't forget to show the tiny thorns on the "knife-arms." The third jointed section is a smaller elongated stroke. Use the tip of your brush for the ending points.

Paint the second pair of legs as line work, using a slight hesitation to form each joint. Your Best Detail brush will deliver a rounder stroke than the Happy Dot. You'll probably be painting slowly, so make sure your brush is dry.

While insects' legs may look fragile, they're the powerhouse of these creatures. They certainly can skip and hop about in amazing ways—try to show that quality in your painting.

The third and longest pair of legs give you the chance to indicate movement. Each joint area is a bone stroke, just as if you are painting a thin branch.

To paint the front legs, or "knife-arms," begin with no pressure, quickly establish pressure, and then quickly release.

I prefer camouflaging this carnivorous creature, hiding him somewhat in his environment. You do not need much in the way of surrounding foliage. Remember, he is the star of the show, so just a few rough strokes will suit him fine!

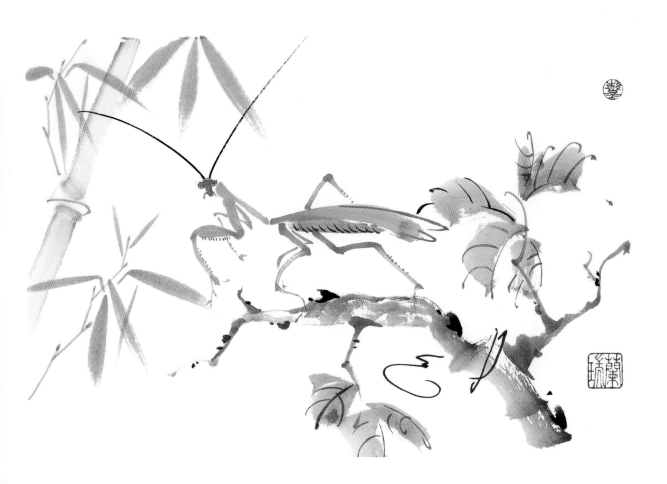

Dragonflies and Damselflies

When dragonflies are at rest they hold their wings straight out to their sides. Contrastingly, Damselflies hold their wings above their back when at rest. Damselflies are also thinner and more delicate in appearance.

The wings are painted the same as those of the Mantis (see page 116). For the outline and vein detailing, think lace and you've got it. Here, it's the wings that get the attention, so place less emphasis on the legs. In fact, you may even omit them in some views.

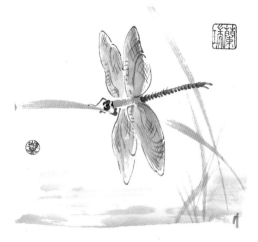

Dragonflies have a Yellow Green thorax. The abdomen is Violet Blue or Neutral Tint; the wings are clear and translucent Cobalt Green and Phthalo Blue.

A Red Skimmer Dragonfly is Red with Brown on the head, has a Brownish-Red thorax, and Yellowish wings with Red veins. Use the tip of a dry Happy Dot brush to outline the heart-shaped head.

The Ebony Jewelwing, which is a Damselfly, has a Metallic Green body with Black wings. This creature is a great subject for Ink only!

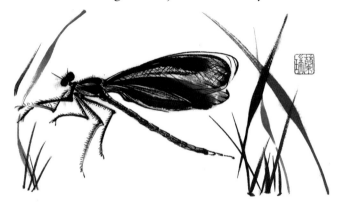

Of course, these creatures, as well as butterflies, are really closer to fantasy. Feel free to paint them in the colors of your dreams.

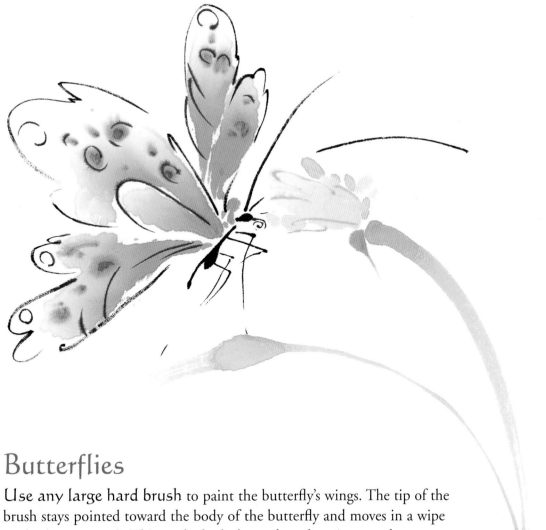

Butterflies

Use any large hard brush to paint the butterfly's wings. The tip of the brush stays pointed toward the body of the butterfly and moves in a wipe stroke (see page 27). This stroke looks best when there is more than one color loaded on the brush. Be sure there is a section of clear water on the upper portion of your brush; do not work the color more than halfway up (refer to the section on Color Blending on page 32).

When the wings are barely damp, dot them randomly with a harmonizing color.

Indicate the head and body with the tip of a very dry Best Detail brush and undiluted Ink.

Make a very free flowing outline of the wings and dots with the tip of a very dry Happy Dot brush and undiluted Ink.

Paint the antennae and legs with a dry Happy Dot brush.

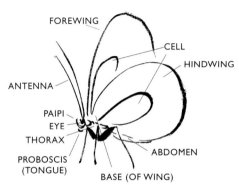

Grasshoppers and Crickets

Grasshoppers and Crickets are the songbirds of the insect world. The main aspect of these insects is their strong hind legs. The femur, or upper section of these legs bulge with muscles, while the tibia, the lower section, is thin and straight.

The Grasshopper's wings are painted with Yellow Green, the abdomen is Burnt Sienna, the head Raw Umber, and the legs are filled in with Phthalo Blue. Use a Happy Dot brush for thin lines and a Detail brush for the rest. If your brush misses a portion of the paper, do not try and fill in the area. The viewer's eye will do that.

Define the wings with undiluted Ink. Place the brush tip on the paper, holding the brush at a 45-degree angle, and flick the tip inward. The lower portion of the back legs are indicated with a bone stroke. Use a modified bone stroke for the front legs. Apply slight pressure on the tip and flick out. For the eyes, apply pressure, and then flick the tip inward. Use a dry brush to form the top of the body. Place the tip facing the head, then pull back.

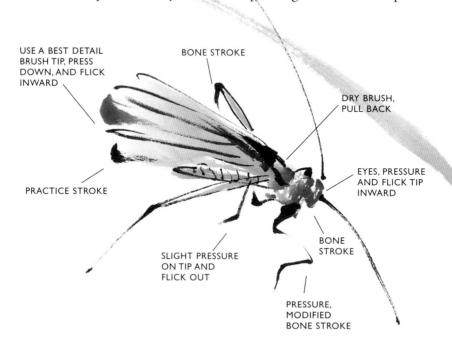

USE A BEST DETAIL
BRUSH TIP, PRESS
DOWN, AND FLICK
INWARD

BONE STROKE

DRY BRUSH,
PULL BACK

EYES, PRESSURE
AND FLICK TIP
INWARD

PRACTICE STROKE

BONE
STROKE

SLIGHT PRESSURE
ON TIP AND
FLICK OUT

PRESSURE,
MODIFIED
BONE STROKE

Captivating Creatures

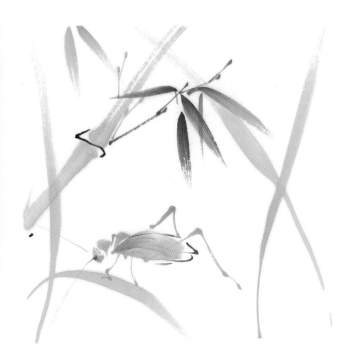

The Cricket is a simple fellow. His wings are done merely by pressing down on your brush and lifting up. Paint an outline extending past the wing shapes you just created. For the head area, place the brush tip on your paper, holding the brush at a 45-degree angle. Then, flick the tip toward the body, keeping the flick centered in the stroke. Paint the legs in the same manner as that used for the front legs of the Grasshopper.

BRUSH:
Detail

MOISTURE:
Dry

COLOR:
Chinese Red or
French Red

Ladybugs

Use the tip of your Detail Brush to paint two semi-circles in Red that together form an elongated oval. Let the Red almost completely dry. Then, with strong Ink and your Detail brush, paint the circles or dots on the Ladybug's body. Next, with Ink and the tip of a dry Happy Dot brush, paint the legs and features on the head. You may add a slight outline to the body and a slight line down its center. Highlight the head with Yellow.

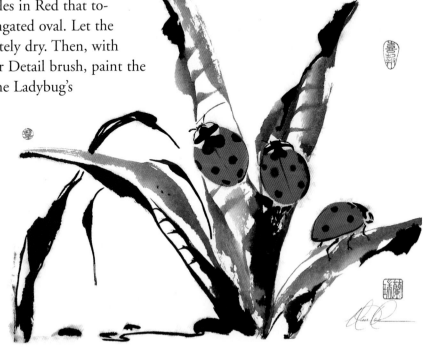

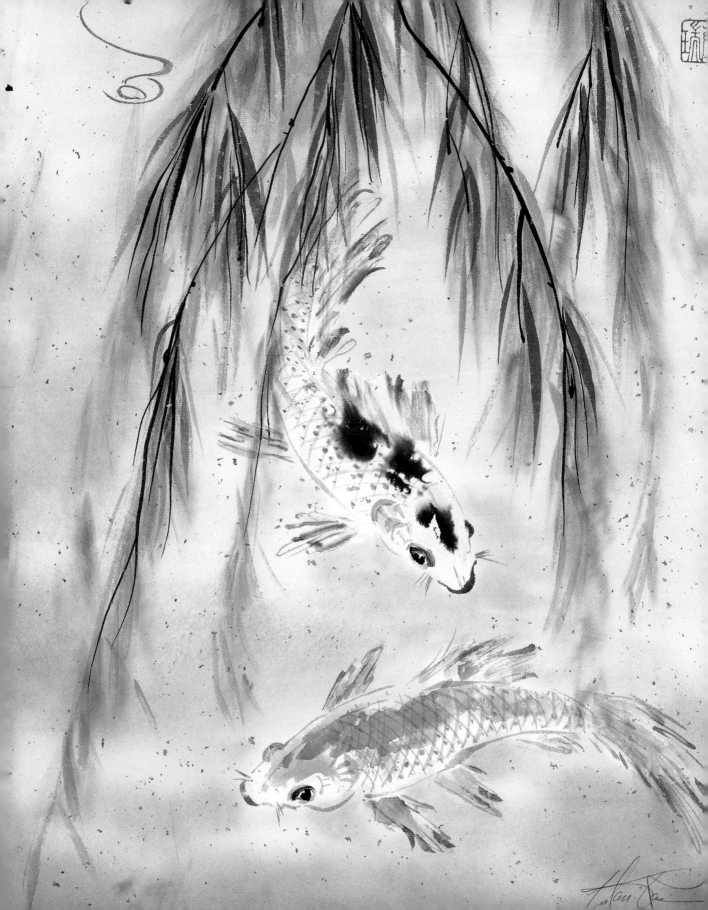

Fish

Carpe Diem

Fish symbolize transformation and varying states of being, in addition to vitality, fertility, and abundance. Even before the Northern Sung Dynasty (960–1280), fish were seen as an artistic study of unfettered existence. The Chinese style of painting fish swimming in their natural environment is most unique—totally subjective, the artist becomes the fish, freely expressing the joy of life.

The Common Carp

Outline the Carp head and body using the tip of your Best Detail brush held vertically. The brush should be very dry and the color a pale tone of Ink. Paint the eye/eyes with undiluted Ink and then outline with a paler tone of Ink. With a dry Big Idea brush and a medium tone of Ink, make wipe strokes to indicate the fins. Line the fins in a deeper tone. Vary this line work for added interest. Let dry, then wipe the entire body with a damp brush. Do this very lightly using water only so that it is barely damp. Using a Large Orchid Bamboo or Soft brush, fill in the body with a pale to medium Blue/Black tone, placing the strongest tone at the top of the head. Add the crosshatching on the body using curved lines. This is done while the Carp is slightly damp, using the tip of a very dry Best Detail brush held vertically. With a somewhat deeper tone, place a dot at each intersection. Place pale Vermilion below the eye.

OPERCULUM

BARBELS

The Golden Carp

Follow the same steps used to outline the Carp, but paint the body of the Golden Carp with pale Yellow instead of Blue/Black, and let dry. Dampen the body again with clear water and let dry until barely damp. Place a thin coat of White over the body and fins. Add the crosshatching on the body using curved lines done in pale Ink. Do this while the Carp is slightly damp using the tip of a very dry Best Detail brush held vertically.

The Shiro Bekko, or triple-colored Golden Carp, can be Yellow on top with Black dots on the head and upper body.

Place thicker White dots in each crosshatched area. Apply some White to the operculum and barbels. Place a Blue half circle above the eyes and pale Vermilion under. To indicate a Red and White Golden Carp, place Vermilion mixed with a small amount of Red on the back in the same manner as you indicated the color of the Common Carp. Dot the top scales with a deeper Vermilion plus Red tone in each of the crosshatched areas.

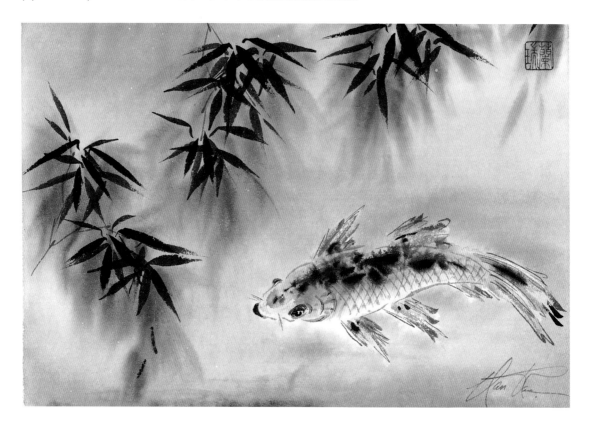

Goldfish

What is more fun than a delightful Goldfish? These captivating creatures are so easy to paint and, in fact, look their best when accomplished with just a few carefree strokes.

HEEL TIP

Use your Big Idea brush to paint the top of the head. Load the brush first with Chinese Yellow and then tip to Vermilion, blend in and then re-tip to Vermilion. Try to keep a water base in the heel of the brush, and then Yellow which blends into the Orange tone as illustrated. Work at having a smooth transition of color. Place the brush flat on the paper and lift straight up. If you see that the stroke is not wide enough, press on each side of the brush before lifting.

Outline the eyes, mouth, and gills in a medium tone Vermilion using the tip of a dry Best Detail brush. Paint the small fins, do a light outline of the body, and place the crosshatching.

Now for the exciting part: the tail strokes. Use your Basic Soft brush with medium moisture. The tip of your brush is placed to connect with the body of the fish. Begin with no pressure, press down halfway on the brush, and swing it around and up off the paper. Do not ease up on the pressure as the stroke is being completed. The hairs of your brush will automatically split as you complete the stroke with a flourish—great! Three strokes usually work best. Follow up with line work to bring it all together.

LINE WORK

Don't forget to hold the paper with your free hand to prevent it slipping as you manipulate the brush.

DORSAL

The dorsal fin may be done either from the top wiping down or from the fish going upward.

Place a small amount of Ink in the eye area you have painted; be sure to use thick Ink. Wait until this area is almost dry, then use Cobalt Green to enhance the area around the eye. To finish, wipe through the body and face of your Goldfish with color if needed.

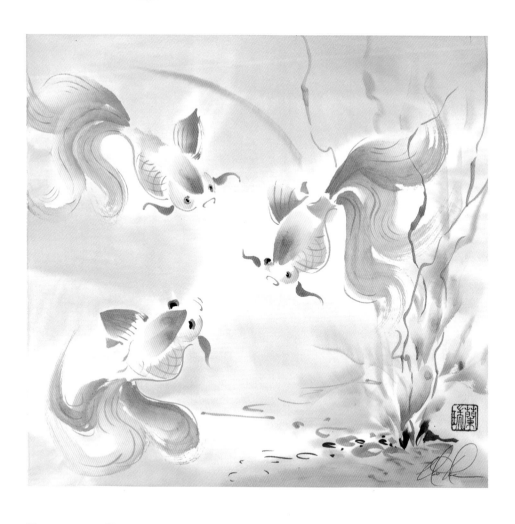

Dragon-Eye

Outline the head and body of your Dragon-Eye using the tip of your Best Detail or Big Idea brush. The brush should be dry and it's best to use a light Ink tone or Neutral Tint.

Paint the fins using the side of your Big Idea or Basic Soft brush. Use a light to medium Ink tone and remember to keep your brush on the dry side.

With a Basic Soft brush, make dramatic wipe strokes to form the tail. When you initiate the stroke (at the end of the body), manipulate the tip of your brush by positioning it sideways at the center of the end of the fish. Press down and maintain the pressure as you swing the body of the brush away from the fish; release off the paper when the stroke is completed. You will need to do at least three strokes to complete the tail. Be sure to leave enough empty spaces as shown. Your moisture is medium to wet and the Ink tone is also medium.

While the fins are still damp, paint on lines and dark spots. Wash the body with clear water using a quick wipe stroke. Note: Don't get the body too wet.

Place a large black spot on the back and head of the Dragon-Eye. These should be irregular in aspect. Using your Big Idea or Soft brush, paint Vermilion plus Red on the back as shown. You will want a pale to medium tone for this.

Using a wipe stroke, place pale Cerulean Blue on the belly and a deeper Blue tone on the eyes. Place rows of White dots/scales on the abdomen (Blue area) and a few in the Red areas. While still damp, dot the tail with Ink. These too should be irregular and placed randomly. All the dots look best when they bleed slightly and cause fuzzy edges.

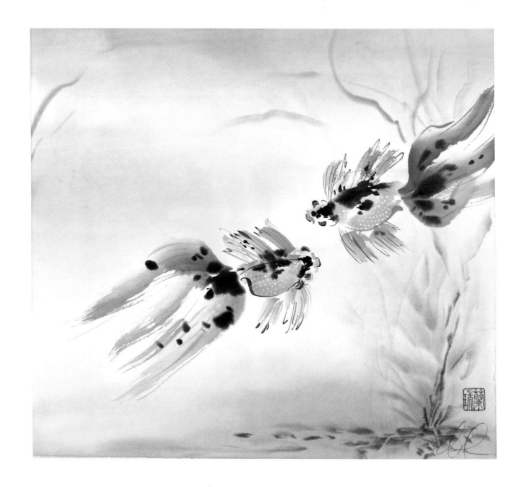

Background Enhancements

Now all that is needed are a few water indications and aquatic plants. Experiment with different backgrounds, working at getting more than one color in the water. Here, as with fish, you will learn by doing an entire painting.

A few, well placed aquatic plants will help to define the fish's environment. You may wish to paint the plants first and then the fish. That will allow you to have the fish partially hidden behind the foliage. Remember, the key here is enhancements—these elements are merely aids in placing your fish in their environment. So, keep them subtle and secondary. Let your colors be muted and your brushstrokes very free and loose.

Other background
enhancements include:

BAMBOO

WILLOW

1. The tropical Banana plant,
which often grows near
ponds, has drooping leaves that
invite the fish to delight in their
shade. Since the leaves are large,
you might want to indicate a por-
tion of your fish peeking out from
under a leaf.

2. Dramatic Lotus leaves and lovely
Lotus blossoms may also accompany your
beautiful fish (see pages 68 to 77).

BANANA

3. Gentleman Bamboo is a fitting companion any time. You
do not have to indicate the culm of the Bamboo or many
branches. Pay special attention to the rhythm and grace of the
branches and leaves that you do indicate. Perhaps you can indicate
the Bamboo in an upper corner and trailing downward.

DUCKWEED

4. Willow will be executed in somewhat the same manner as
Bamboo, but keep in mind its more delicate aspect and the
fewer leaves that descend from each long twig. Let these curve
gracefully. You may wish to indicate a portion of a Willow branch
at the top. Do this in a manner similar to a Wisteria branch (see
page 52), only smaller.

5. Wisteria adds a beautiful aspect (see pages 46 through 53).

6. The common Duckweed may also be painted and looks much like a Lily
pad. A grouping of three, five, seven, or more is lovely. Be sure to vary the
sizes somewhat. Your Big Idea brush is nice for this.

It was the Chinese artists who first painted fish underwater, and nothing is more Asian than placing darting creatures in their watery element. To capture that same appearance, after your initial painting is dry, turn the paper face down and wet the entire back with your large Wash brush (Hake). While waiting for the paper to dry to barely damp, make a reservoir of Phthalo Green Deep plus Charcoal, Indigo, or Neutral Tint. This reservoir should be somewhat light in tone.

Load your Wash brush from the reservoir and sweep across the paper starting at the top. You want these strokes to cross the paper in a straight manner. As you approach your fish, stay at least one-quarter inch away from the border of the body to prevent coloring the fish. You may add Cobalt Green and Phthalo Blue in some areas for highlights.

To finish, paint in the shadows of the aquatic plants or background enhancements. If there is too much white space around your fish, use a small Soft brush with your water's color and gently fill in.

"Fish must be painted swimming and darting with vitality. ...As they float on the surface, dive, or glide among the water grass, the clear waters envelope them or ripple off them. Deep in one's heart, one envies them their pleasure."

–The Tao of Chinese Brush Painting, 17th century

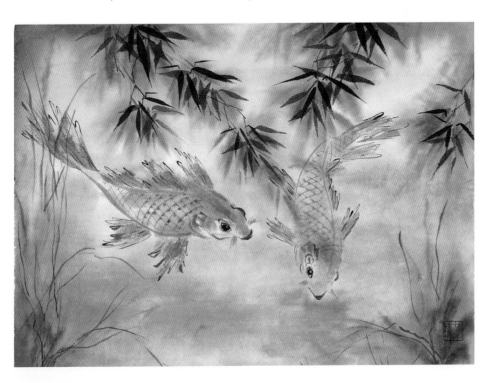

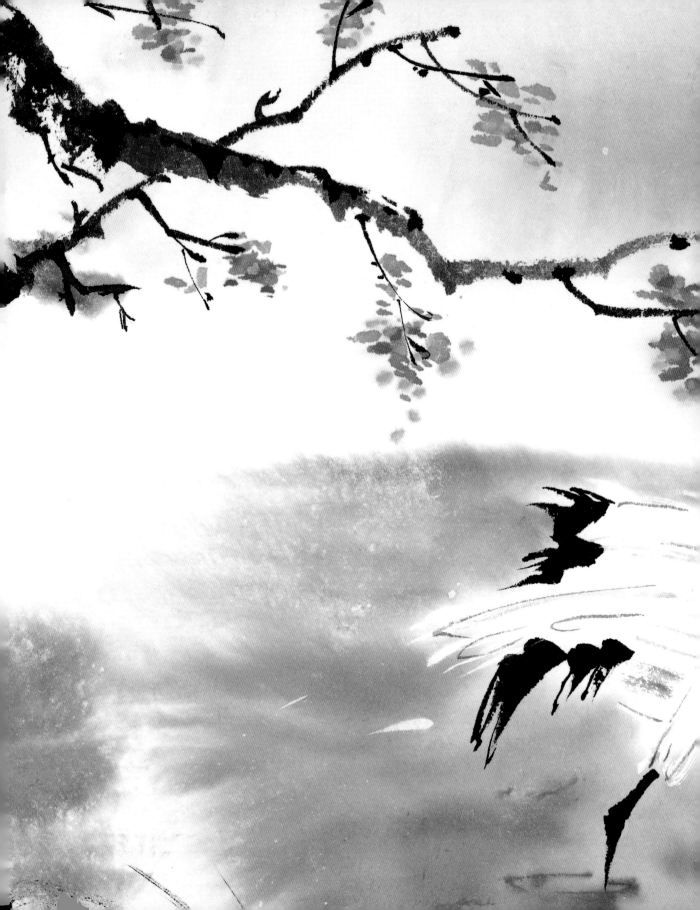

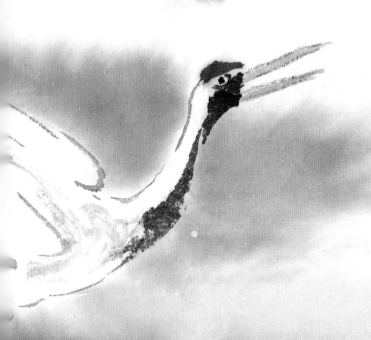

Finishing Touches

The Chinese Chop or Seal

In Chinese and Japanese painting, the personal chop or seal establishes the artist's identity and is used to authenticate the painting. This authentication seal is more important than the artist's signature, which serves only as a secondary identification. The artist also may use mood or side seals to convey transcendent themes.

In ancient China it was customary for each successive owner of a painting to add his own personal seal to that of the artist. This custom provides a valuable history of the work and accounts for the proliferation of seals found on old master paintings. In those dynastic days, only persons of great privilege, wealth, and position could own or sponsor such works of beauty.

Seals are either carved in relief so that the characters appear in Red on a White background, or intaglio so that the background appears in Red and the symbols are White. As you will see in my collection, it is important not only to have a variety of shapes but also seals carved in both relief and intaglio. In years past, seals were carved from elegant materials such as jade and ivory; today, most are carved from soapstone. Many have interesting flowers or figures carved on the side or top of them, making the seals themselves aesthetically pleasing. Seals are great fun to collect. If you find an interesting-shaped seal that is uncarved on the top or side, you can have your own saying carved on the stone.

For your name, I recommend a name chop or seal that is carved in relief and about three-quarter-inch square. Your name will be translated phonetically with a Chinese character representing each syllable. The carver will pick the loveliest meaning for your sounds.

I place a maximum of two mood seals in addition to my personal chop on any painting. Mood seals are used to enhance your painting, so great thought is given to their placement. Before making your imprint, take little pieces of paper with your seal imprints and move them about on your painting until you are pleased with the placement. A triangular seal placement works well, as does lining up the seals to balance the composition. Whatever placement you choose, always keep your seals along the borders of the painting.

Making a Good Impression

Seals usually come with a little tin container of Red Cinnabar Ink paste. This paste is inexpensive and will last a long time. If desired, you may purchase a more elegant ceramic dish filled with paste.

Lightly press your seal into the paste several times and, as you do, blow on the seal to help warm and soften the paste. Always test the seal first on a piece of painting paper. If the imprint looks good, tap the seal into the paste a few more times, and then place it on your painting in a firm manner. Do not wiggle the seal around or you will blur the image. Just exert firm pressure on it for a moment, and then lift straight up. To get a sharp image, place a magazine under your painting before stamping. As an undersurface, a magazine offers just the right amount of yield and support. A softer undersurface can wrinkle the paper, while a harder undersurface could result in a poor contact. Practice placing your seals so that they appear straight. Always completely wipe off your seal before putting it away.

This personal authentication seal says "Auspicious Orchid," my Chinese name. It is Red with a White background carved in relief.

Mood Seals

Mood or Side Seals convey transcendent meaning. Here are some seals in my collection shown true to size.

This mood seal means "Harmony of Heaven and Earth," a recurring Chinese theme. It is an intaglio carving, White with a Red background.

This mood seal means "Constant Hope," an imperative theme of life's survival. It is also an intaglio carving.

Small and circular, this mood seal, also an intaglio carving, extols in its sublime meaning the principle of "Ideal with Tradition."

"Discovering Oneself Midst A White Cloud on A Secluded Mountain." Large and imposing, this mood seal is intended to emphasize a dominant theme of self-understanding through tranquility. It proclaims the human aspiration of harmonious self-discovery in a personal hiding place or Shangri-La. More sublimely, this seal suggests a journey into the symbolic mist of *Shan-Shui* (Mountain/Water)—meaning Chinese landscape, the loftiest form of Chinese brush art. In *Shan-Shui*, the viewer focuses on the landscape mist and in it sees a powerful fusion of universal themes.

Here is another intricate seal, charmingly small and circular. This delicate carving beautifully expresses a sublime "Simplicity"—one of the highest principles of Chinese philosophy and tradition.

"A Branch of Grace Blossoms in the Valley." Here is a seal that broadly symbolizes the strength, power, and virtue of life. As in many cultures, in Chinese brush painting, branches and trees represent vitality (life) and hardy longevity—a quiet, gentle, yet inexorable power. This seal embraces the eternal essences of life and virtue.

This small, square, and intricate seal expresses the beauty and essence of the universally prized quality of "Purity."

"Floating Petals in the Stream and Thoughts of Meditation Together Compose One Harmony." This poetic thought transcends the everyday and places one in a sublimely peaceful setting.

"Smooth like Silk." In its simplicity, this seal represents luxury and sensate experience. It suggests a spiritual reflection of the artist's skill in creating that quality of fineness and human perfection.

"Reporting of Good News." He who brings good news is to be honored above all persons. This is the eternal symbol of hope and human aspiration in its vision of harmony.

The lace-like craftsmanship of this unusual seal quite wonderfully matches the meaning of the depicted philosophical quotation from the famed and venerated poet of the T'ang Dynasty (616-908), the celebrated Po-Chu-Yi.

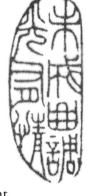

> "Even before the tune came
> There was passion in the air."
> From the 'pi-bar Song' of Po-Chu-Yi

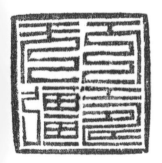

There are times your painting calls for a big statement. When I found this mood seal with it's magnificent carving of a dragon on top, I knew it had to be in my collection. There are four characters seen in this carving. The upper right says "10 thousand"; below that we see "longevity." In the upper left the symbol says "unlimited" and below that "territory." It all combines to say "Travel a thousand miles in an unlimited life." What a lovely way to say longevity!

"Life Spent Like This Would Be Joyful Indeed."
The thought of artists everywhere!

Mounting Your Artwork

MOUNTING SUPPLIES

1. A smooth piece of plywood board that is 24 by 35 inches or larger.
2. Metylan Standard Clear Cellulose Adhesive (distributed by Loctite Corp., Rocky Hill, CT 06067; available at paint stores).
3. A plastic tub with lid to mix and contain the paste.
4. A wallpaper applicator (although I prefer to use my hands).
5. Acid-free barrier paper (single-ply rag board). The most common size is 32 by 40 inches.
6. Krylon #1303 Crystal Clear spray from a paint or hardware store.
7. Carpet cutter and Xacto knife.

Mounting not only helps to preserve your beautiful paintings, but it also takes out the wrinkles and provides a stronger, less fragile piece of paper. There is a certain touch to this process, so learn and experiment with some less interesting paintings before attempting to mount one of your masterpieces.

Place your personal chop and additional mood seals on your paintings before mounting them. You cannot get as clear an impression after the painting is mounted.

Making the Paste

Mix one (1) cup of cold water for every level tablespoon of Metylan paste, stirring constantly while slowly adding the water. Because of atmospheric conditions, you might add more or less than one cup of water to achieve a paste that is a little thinner than honey and a little thicker than egg whites.

Let the paste stand for fifteen minutes while stirring every three or four minutes. After fifteen minutes, gradually add more water if needed to ensure a smooth consistency as described above. Remove any visible lumps.

Cover and refrigerate the paste for twenty-four hours to allow the mixture to develop correctly. The paste may be stored in the refrigerator and used for several weeks. Even so, for the best results, do not make more than two cups of paste at a time.

The 15 Steps

1. When your painting is thoroughly dry, spray the areas of concentrated color with clear acrylic sealer to prevent color-run. (By concentrated color, I mean those areas of the painting in which the color is deeper and richer.) This is an extremely crucial step and should be done outside when it is not windy. While spraying, hold the can at least ten inches away from your painting. Do not over-saturate; you want a thin film. I like to do a quick spray, wait a moment, and then do another. Light color washes or pale colors should not be sprayed, as the more area you spray, the more difficult it will be to spread the paste.

2. Cut a piece of barrier paper six inches wider and six inches longer than your painting to have a three-inch border around it; set the paper aside temporarily. Stand your plywood securely on end so you can walk up to it with a damp painting in hand. If your plywood is only slightly larger than the barrier paper, you may place your board flat on a table.

3. Place your painting face down (very important!) on a smooth non-porous surface; a Formica surface is ideal. Other non-porous surfaces are glass, Plexiglas, or polyurethaned wood.

4. Scoop up a handful of paste and start at the center of your painting. With your fingertips, spread the paste evenly using an outward motion, first toward the top half, and then the bottom half of the paper. Add more paste as needed.

 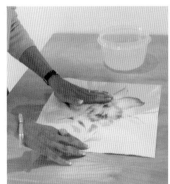

 The paste must be applied evenly over the entire back surface of the painting to the very edge of the paper. As you spread the paste, very gently pull the paper in the same direction as you are applying. This is very important because it helps to prevent wrinkling.

 Check carefully that there are no excess globs of glue. Don't worry about air bubbles; you will be able to remove them in the very next step. Also, if you see a wrinkle or two, do not try to correct it at this point. It is normal for the paste to bleed through the painting, causing it to be lightly tacked to the smooth surface.

5. Pick up the barrier paper and starting at one end of the painting, center your barrier paper three inches outside the painting edge, then slide your hand to guide the paper down smoothly onto the wet painting, leaving a three-inch border on all sides. The painting should be centered underneath the barrier paper.

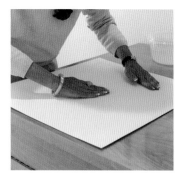

6. Starting at the center of the barrier paper, with strong pressure and even strokes, use your hands or wallpaper applicator to press evenly and very firmly in an outward motion toward all the borders. Be certain you have pressed down on all areas of the paper. Done correctly, this step removes any air bubbles and wrinkles that remain.

7. Now, apply a one-inch border of paste around the outside edge of the barrier paper. You will adhere the painting to the plywood board in the next steps.

Lift up the barrier paper from one corner, as though you were peeling it gently away from the mounting surface. This gentle peeling helps prevent tearing the paper.

8. The painting and barrier paper should be firmly bonded by now. Starting at one corner, gently lift up the barrier paper and your artwork will come with it.

9. You should be facing the painting at this point. Being careful not to let the paste borders touch each other, walk up to and place your artwork on the plywood board. Be sure that the entire one-inch border of the barrier paper, where you applied paste in Step 7, is completely pasted to the board.

10. Do a final check of the painting making sure all edges are flat. If you see any air bubbles, place a small amount of paste on the bubble and gently work it off to the border of the painting. For wrinkles, apply a small amount of paste and work out with the full area of your index fingernail. If some color bleeds, gently tap with a paper towel.

11. If parts of the border pop up when drying, tape them down with masking tape. You do not want any air pockets; air pockets cause buckling.

12. Allow the painting to dry on the plywood for about twenty-four hours.

13. When dry, remove the painting from the board by cutting the barrier paper at least an inch away from the painting. With your Xacto knife, slowly and carefully cut the paper away from the plywood. Be sure to leave an inch or more barrier paper border around the painting—you will trim it later. When cutting, be sure to cut firmly but carefully.

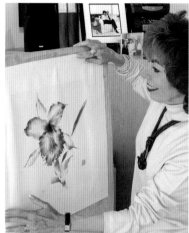

14. Set your artwork aside, and tear off (by hand) and throw away whatever remains of the pasted border on the plywood. While you'll want your board to be reasonably clean and neat, you will not be able to remove all of the excess paper. More and more bits of paper will stick to the board as you continue to use it to mount your artwork.

15. Pencil sign your beautiful painting.

The Chinese masters teach us that patient and careful attention to all details is of supreme importance in Chinese brush painting. You cannot hurry when mounting a painting. You will find as you progress that the mounting technique has a mind of its own, and it demands strict care and adherence to the standards set by two millennia of unhurried Chinese artistry. These are the standards intended to cultivate a civilized society and nurture the whole person in the discipline of Chinese brush art. They will become your standards, too, and, in fact, will become a part of you.

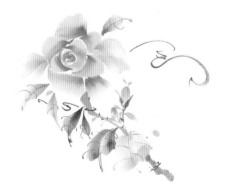

I celebrate your beautiful painting!

Suppliers

Watercolors, mixing dishes, some brushes and papers are available at local art stores. Your local retailer can also advise you on purchases, and if you need something they don't have in stock, they may be able to order it for you. As you progress, you will want genuine Chinese brushes and Double Shuen paper. As these are made by small Chinese manufacturers, you will have to visit or contact a Chinese supplier of art materials and equipment. If your community has a "Chinatown" area, you are in luck. When purchasing brushes, examine them carefully, as quality control is uneven; some Chinese shops will let you try the brush before buying. Chinese brushes and paper are also available on my website at www.nanrae.com. You will also have to go to Chinatown to purchase seals. There, you will find craftsmen who will gladly carve a name seal or phrase from soapstone blocks while you wait.

If you are not near a large city with a Chinatown area, you can order special art supplies from the following mail order sources:

Chinese Cultural Center
970 N Broadway
Suite 103
Los Angeles, CA 90012

Chinese Culture Co.
736-738 7th Street
Washington, DC 20001

Chinese Culture Co.
126 N 10th Street
Philadelphia, PA 19107

Co-op Artists Materials
PO Box 53097
Atlanta, GA 30355

Denver Art Supply
1437 California Street
Denver, CO 80202

Guanghwa Co. Ltd.
32 Parker Street
Covent Garden
London WC2B 5PH

Harvard Square Art Centre
17 Holyoke Street
Cambridge, MA 02138

New Unique Company
838 Grant Ave, Mezzanine
San Francisco, CA 94108

Oriental Art Supply
PO Box 6596
Huntington Beach, CA
92615

Oriental Cultural
Enterprises
22 Pell Street
New York, NY 10013

Zhen Studio
PO Box 1060
Pinole, CA 94564

About the Author

Nan Rae trained as an artist in the Western tradition at the Art Institute of Chicago, the University of Tulsa, and the University of Colorado. A visit in 1980 to Monet's home in Giverny inspired her study of Chinese brush painting, and she has lectured on and taught its techniques since 1984. She currently teaches classes in Chinese brush painting at the Huntington Botanical Gardens and Library in San Marino, California. Her work has been featured in many important international exhibitions, including the Grand Palais in Paris and the Osaka Festival of Art in 1994, and is included in private and corporate collections throughout the United States, Canada, Europe, and Asia. She lives in Burbank, California.

About the Photographer

Photographer Chuck Bowman is a well-known television director and producer whose second vocation is celebrity portraiture. He has over 150 network directing/producing hours to his credit, including many Movies of the Week and series such as *Dr. Quinn, Medicine Woman, The Pretender, Alien Nation* and *Profiler.* A Kansas native, Chuck was a radio announcer in the Midwest and a Los Angeles television reporter before turning to commercial television. Photography has been a constant passion throughout his life.

Index